HERITAGE CRAFTS TODAY

Fraktur

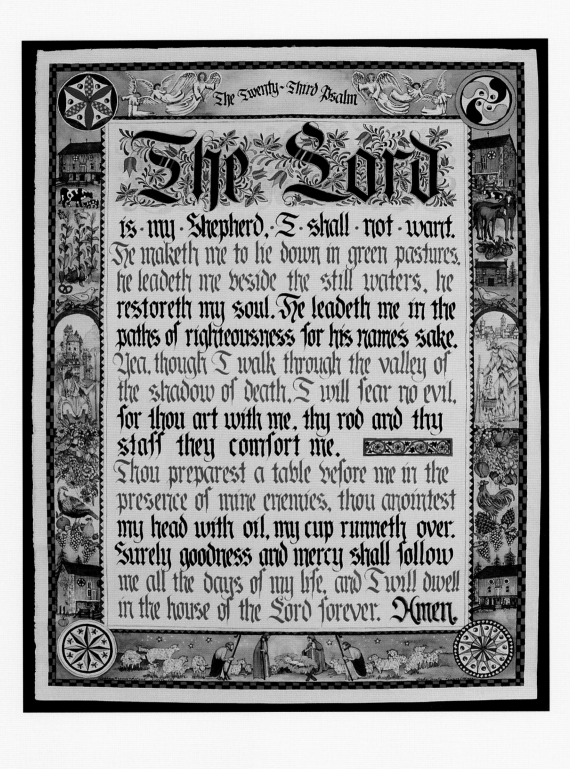

The Twenty-Third Psalm

The Lord is my Shepherd, I shall not want. He maketh me to lie down in green pastures, he leadeth me beside the still waters, he restoreth my soul. He leadeth me in the paths of righteousness for his name's sake. Yea, though I walk through the valley of the shadow of death, I will fear no evil, for thou art with me, thy rod and thy staff they comfort me. Thou preparest a table before me in the presence of mine enemies, thou anointest my head with oil, my cup runneth over. Surely goodness and mercy shall follow me all the days of my life, and I will dwell in the house of the Lord forever. Amen.

HERITAGE CRAFTS TODAY

Fraktur

Tips, Tools, and Techniques for Learning the Craft

RUTHANNE HARTUNG

STACKPOLE
BOOKS

Guilford, Connecticut
Blue Ridge Summit, Pennsylvania

STACKPOLE BOOKS
An imprint of Globe Pequot, the trade division of
The Rowman & Littlefield Publishing Group, Inc.
4501 Forbes Blvd., Ste. 200
Lanham, MD 20706
www.rowman.com

Distributed by NATIONAL BOOK NETWORK

Copyright © 2008 by Stackpole Books
First paperback edition 2022

Photographs by Michael E. Lauter unless otherwise noted
Cover design by Tracy Patterson
Frontispiece: The Lord's Prayer in Fraktur by Ruthanne Hartung

British Library Cataloguing in Publication Information available

Library of Congress Cataloging-in-Publication Data Available

ISBN: 978-0-8117-7135-1 (pbk. : alk. paper)
ISBN: 978-0-8117-7136-8 (electronic)

♾™ The paper used in this publication meets the minimum requirements of American National Standard for Information Sciences—Permanence of Paper for Printed Library Materials, ANSI/NISO Z39.48-1992.

CONTENTS

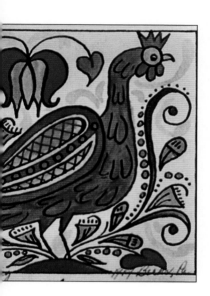

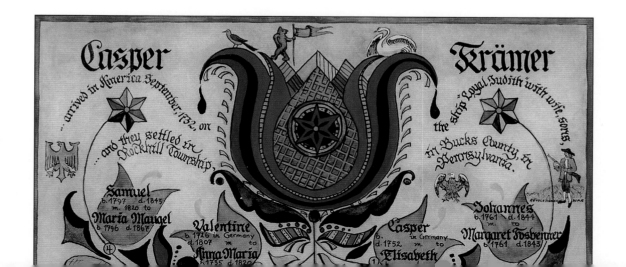

ACKNOWLEDGMENTS

Special thanks to my family for their patience and assistance; my sister, Mary Jane Kramer, for the expert computer skills used in preparing the manuscript; Barry Fehnel, for his assistance; Michael Lauter, for his creative photography; Kyle Weaver, my editor at Stackpole Books, for his suggestions and guidance in the development of this project; and Don Yoder, for reviewing the history section, offering his expert advice, and providing images of Fraktur from his collection for the Gallery. Many thanks to my friends and colleagues for their interest and support through the years, thus making this book possible.

Over the years, I have seen, heard, and read a great deal of information on Fraktur. If I have failed to document or attribute a source, it is not on purpose; I have simply lost track of the source.

INTRODUCTION

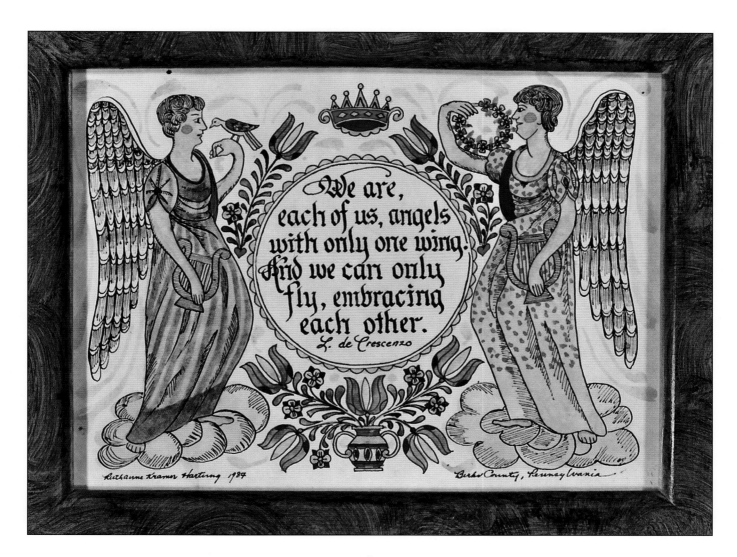

The adaptation of folk-art design and use of modern tools to create Fraktur has been my avocation since 1974. Sometime before that, I had been given a family Fraktur that was made to note the 1846 birth of a great-grandmother. A photo of it is on page 13 as an example of a partially printed form Fraktur. The form was printed in Reading, Pennsylvania, and was wonderfully filled in and colored by Francis Levan, who was noted for his imaginative and colorful style. This Fraktur completely captured my imagination. At the time, I was still teaching art in public schools. The Fraktur was framed and hung proudly in my home.

After leaving full-time teaching, I had more time available to research folk art and experiment with my

Above: Many of the motifs common in Fraktur appear in this piece—angels, tulips, bird, and crown.

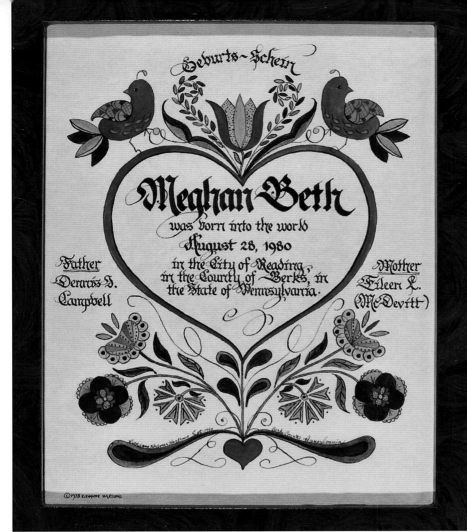

Left: *In this birth certificate, the heart, birds, and flowers are symbols of good wishes on the birth of the child.*

Above: *Ruthanne Hartung in her studio.* PHOTO BY KYLE WEAVER

own drawings. At first people brought commercially printed forms and asked me to letter in the names and dates. Looking at those, I thought I could draw at least that well and began to develop my own drawings into birth and marriage certificates. Side trips into historical research and genealogy resulted in an appreciation of the earlier hand-drawn Frakturs. The techniques used to apply the wonderful designs to sometimes rare and precious pieces of paper reveal the passion to record basic information in a time when one couldn't go to a store and buy ready-made paper, ink, and colors. The labor involved in creating homemade versions of the tools required is impressive. Imagine making a paintbrush from squirrel hair attached to a carved handle or boiling bad-smelling ingredients down to make ink.

As time allowed, classes in lettering and watercolor techniques helped me develop my style. I received a B.S. in art education from Kutztown University and studied watercolor techniques with John Smith and Gothic Black Letter forms with Raphael Boguslav and Paul Shaw in New York City. I visited the Fraktur collections in museums and historical societies to gather sketches and ideas in order to bring the same passion to my work that I

saw in the early pieces. I also traveled in Germany and Switzerland for insight into the origin of my folk art. I took part in craft shows and received feedback and exposure to the ideas of other craftspersons.

Developing a flexible schedule around a growing family, I eventually taught classes and workshops at the Wyomissing Institute of Fine Arts, Reading Area Community College, and Berks County Historical Society. I hope those who attended learned as much as I did from the experience. I've enjoyed sharing with many people the techniques used to create personal Frakturs. I am proud of former students who have continued their interest and developed their own styles, those who still create their own Frakturs, and those who gained a greater appreciation of folk art.

My very interesting journey has now led to a new creation—this book, which is intended for those who love the simplicity, design, and color of folk art, as well as the tradition from which it evolved, and want to enjoy the unique personal expression of Fraktur. Look at Frakturs wherever you find them and enjoy the experience. May the following suggestions and instruction inspire you to continue the tradition of this charming and useful folk art.

A Brief History of Fraktur

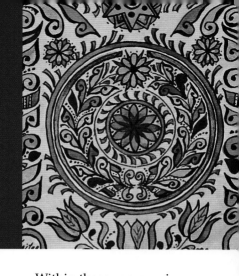

In the centuries between the fall of the Roman Empire and the beginning of the Renaissance, the survival of the arts of hand lettering and illumination depended on scribes and cloistered monks. Beautiful examples of their works, such as the *Book of Kells*, show the skill and devotion of these early monks and scribes. European village communities from the sixteenth century had clergymen, schoolmasters, notaries, and others skilled in arts and letters who produced examples of decorative writing. The motifs and texts used in their manuscripts were based on tradition and passed down over generations within communities. These documents were created to record the vital statistics of everyday life, such as births, baptisms, or marriages, or create genealogical records. Others were blessings for homes. Frakturs sometimes were given as gifts.

These decorative writings were made using homemade papers, inks, and dyes, which were applied with homemade brushes and quill pens by those fortunate enough to learn the arts of writing and decoration. Some very beautiful examples can be seen today in local museums and historic churches in Europe, with motifs similar to those used today.

The migration from Europe to America brought many folk arts to a new audience. The term *folk art* refers to art produced in and for a folk community and based on traditions within the community. In America, this refers to church communities.

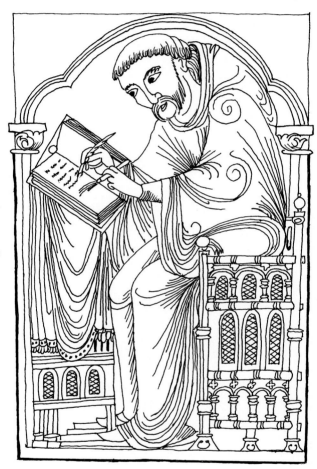

A monk copying manuscripts with pen and brush.

Within these communities during the eighteenth and nineteenth centuries, early German settlers developed a distinctive style of art on paper, and this folk art is now known as Pennsylvania Dutch Fraktur, or *Frakturschriften.* The term *Fraktur* is German in origin and is derived from the Latin *fractura,* meaning "broken letter" and referring to letters that are formed with several lines or strokes of the pen rather than one continuous line. In Europe, the term *Fraktur* applies to both manuscript writing and print lettering.

Fraktur can also be called a "memory art," because the design elements used were those remembered from original European manuscripts or from manuscripts brought here by earlier settlers. The design motifs we still use today were collected, adapted, and passed down through generations in Scandinavia, Central Europe, and Eastern Europe.

The Pennsylvania Dutch art form has subtle differences from the earlier European examples. One is that the birds, flowers, and many other motifs used were those native to the New World. Heraldry symbols were much used in Europe but were no longer seen here in Fraktur produced after the American Revolution. New design motifs emerged to express a new patriotism. Clothed figures reflected the styles of the time in which they were created.

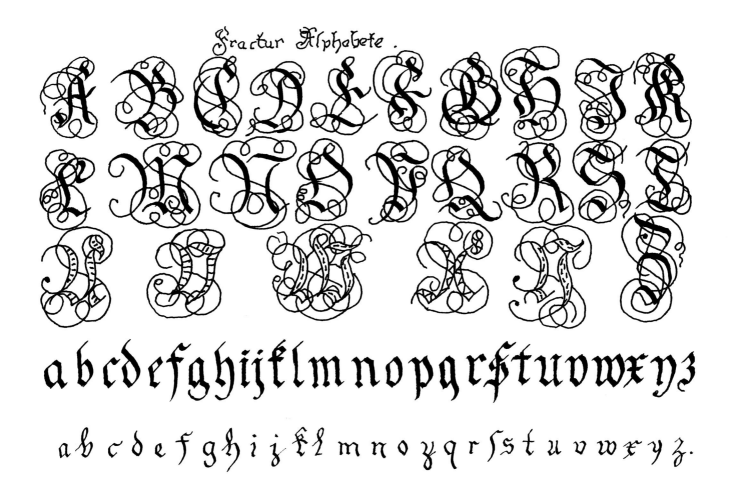

An early Fraktur alphabet from the 1821 Engelman book for Fraktur writers, an original hand-lettered copy book used to learn lettering. It is a refined version of the German Black Letter.

The hand-drawn Frakturs were first produced by schoolmasters and ministers of the church, as these members of the rural community were the first educated in writing. The most widely used style was the Fraktur letter, called the German Black Letter by calligraphers. It was so named because of the dense black areas created when it was written on a page. This style also became known as the Fraktur text letter. In the later nineteenth century, other letter styles were sometimes used. The most common was the easily recognized Spencerian calligraphy style, with its many flourishes. The style used for a Fraktur was the one the writer could master with the most ease.

The first serious collector of hand-drawn Frakturs was Henry Mercer in the late nineteenth century. He established in Doylestown the well-known Mercer Museum, which is full of collections showing his many interests. Mercer was the first to recognize this hand-drawn art on paper as a separate and important genre, which he named Pennsylvania German Fraktur.

Several distinctive styles of Fraktur developed in Pennsylvania communities. Over time, they reflected cultural changes in symbolism. One of the most notable styles was that of the Ephrata Cloister community in present-day Lancaster County. During the 1700s, the largest period of production, community members created especially beautifully decorated and detailed musical manuscripts. Their distinctive style of hand lettering and illumination, or decoration, is well worth the trip to Ephrata to see it in its original form and in its historical surroundings. Unfortunately, some of their homemade inks were very acidic and in some cases ate through the paper. Strict preservation controls are now attempting to keep subsequent damage to a minimum.

Right: *An exact reproduction of an Ephrata Cloister drawing of a pomegranate, circa 1742, taken from a typical stylized music manuscript. Note the extreme detail and limited color palette, although the colors have probably faded in the original.*

EPHRATA CLOISTER, PENNSYLVANIA HISTORICAL AND MUSEUM COMMISSION

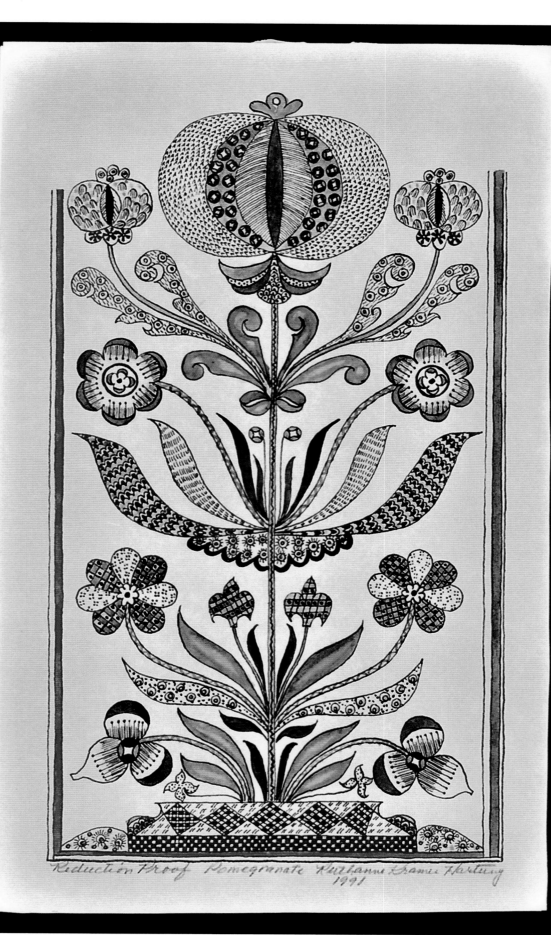

Reduction Proof Pomegranate Keithanne Cramer Hartung
1991

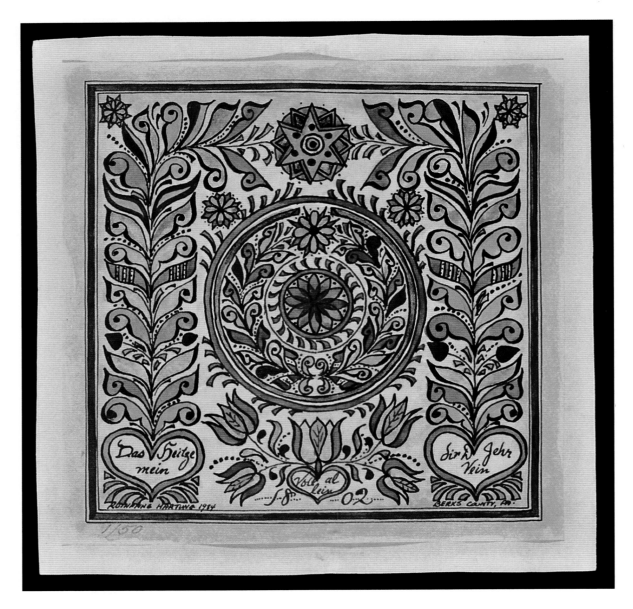

A miniature version of a Schwenkfelder Fraktur. These extremely stylized motifs and bright colors identify the work of this community. Usually the name of the maker or a Bible verse was part of the Fraktur.

Fraktur Terms

Frakturschreiber. Fraktur writer.
Frakturschriften. Fraktur writing.
Buecherzeichen. Bookplate.
Lesezeichen. Bookmark.
Geburtschein. Birth certificate.
Taufschein. Baptism certificate.
Trauschein. Marriage certificate.
Familienregister. Family record.
Haus Segen. House blessing.
Vorschrift. A writing sample by a schoolmaster or
 Fraktur artist.
Belohnung. A reward of merit, usually a small draw-
 ing made by a teacher for a student.

During the 1800s, the Schwenkfelder community in the Pennsylvania counties of Montgomery, Lehigh, and Berks developed its distinctive style with the use of brilliant colors. These colors are a definite counterpoint to the pale and limited color palette used at the Ephrata Cloister. The Schwenkfelders had a drawing style that was a bit more relaxed, even though each piece is full of brightly colored design elements.

The Moravian community's documents from Lehigh County demonstrate the greatest skill in pen work. In the nineteenth century, Mennonite communities led by Christopher Dock in Skippack, Montgomery County, established the first schools for the training of Fraktur writers, or *Frakturschreibers.*

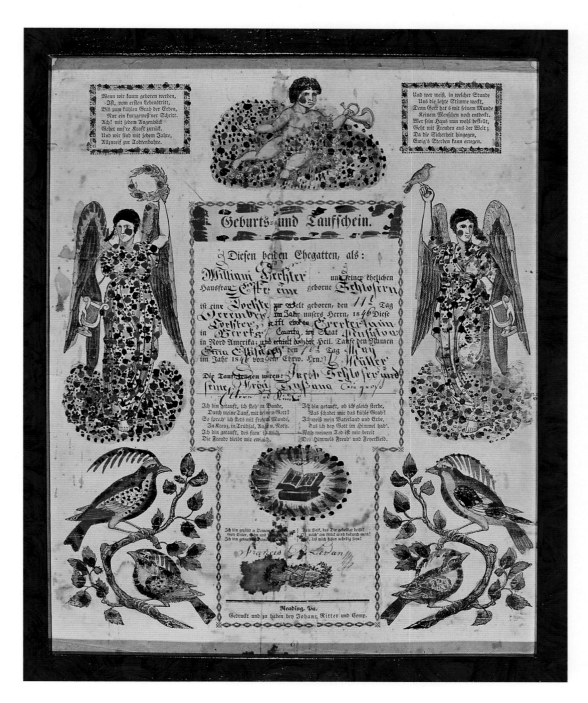

An example of a partially printed Fraktur certificate. Many of these were used in Berks, Lehigh, Schuylkill, and Lehigh Counties in Pennsylvania. This fill-in-the-blank style was common in the 1800s. The lettering and fanciful coloring were done by Francis Levan, a well-known Frakturer in Berks County. AUTHOR'S COLLECTION

Dunkards, Mennonites, and Amish produced manuscripts for use only within their own communities. These Pennsylvania Dutch groups, known as the Plain Dutch, did not produce *Taufscheine,* or birth and baptism Frakturs, because they did not practice infant baptism. But many beautiful *Vorschriften, Haus Segen,* and other documents can be found. Most of the *Taufscheine* were produced by the Lutheran and Reformed communities, the so-called Church People. These groups composed up to 75 or 80 percent of the total population of the Pennsylvania Dutch.

The center for production of partially printed certificate forms was Reading, in Berks County. Popular forms were also printed at shops in nearby Allentown and Harrisburg. These forms were often filled in by itinerant artists who traded their skills for food or lodging with the families for whom the certificates were completed.

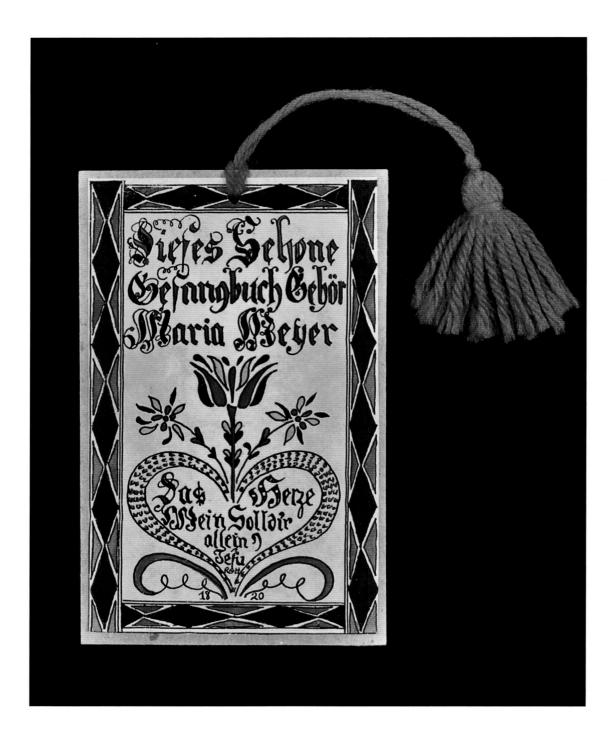

This is a typical design for a *Lesezeichen*, or bookmark.
They were given as friendly gifts from the schoolmaster
at the close of winter schooling, usually at Easter, or as
rewards for outstanding achievement.

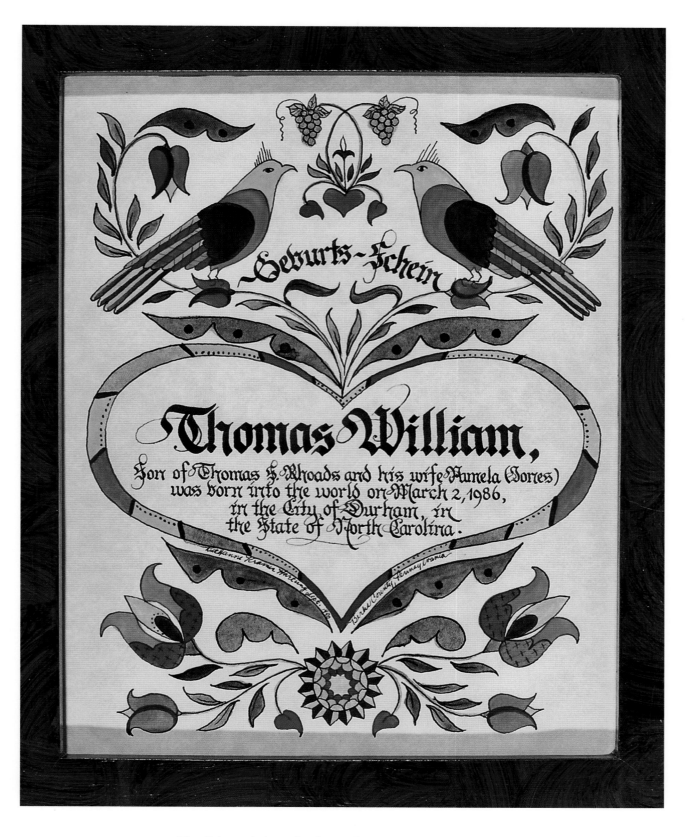

The *Geburtschein*, or birth certificate, is a common form of Fraktur, along with the *Taufschein*, for baptism, and the *Trauschein*, for marriage.

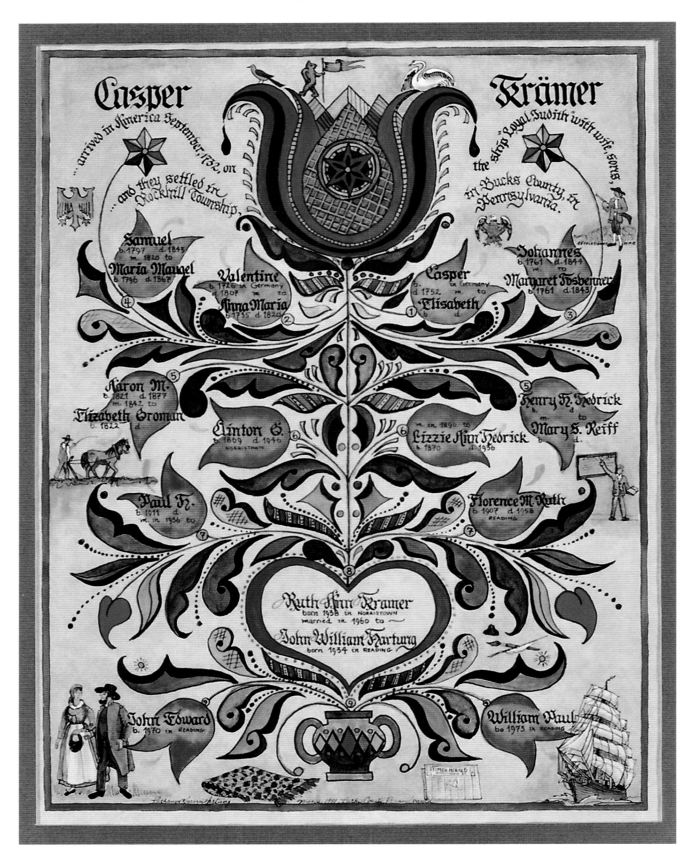

The *Familienregister* is a decorative Fraktur, now known as a family tree. The tulip at the top of this one was inspired by the Great Lily of Ephrata. Each branch represents a generation, which is numbered on the center stem. The illustrations of people represent the occupations of the various family members.

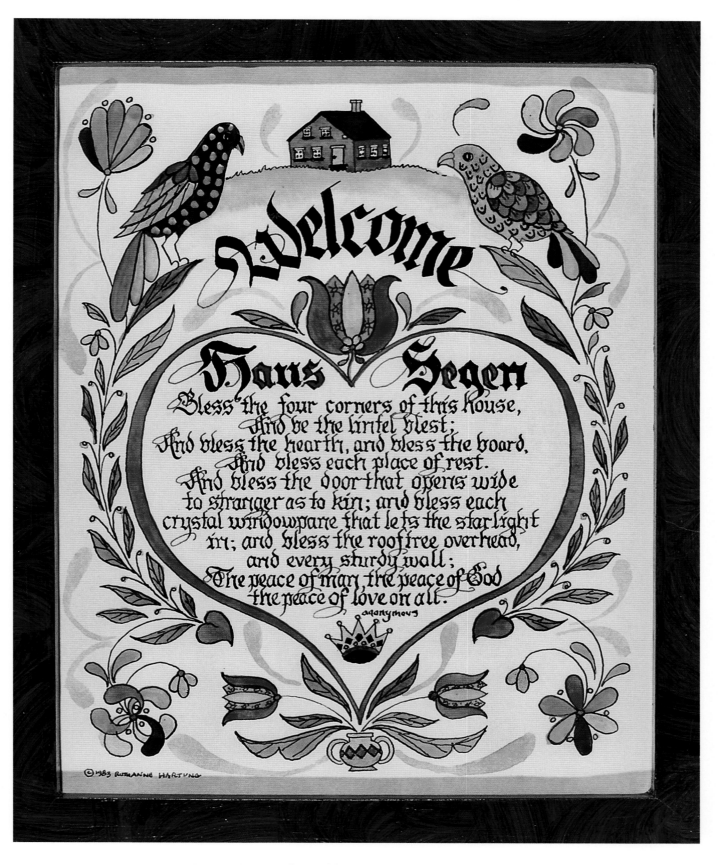

A *Haus Segen,* or house blessing, expresses wishes for
happiness and good fortune to a home and all who
dwell there.

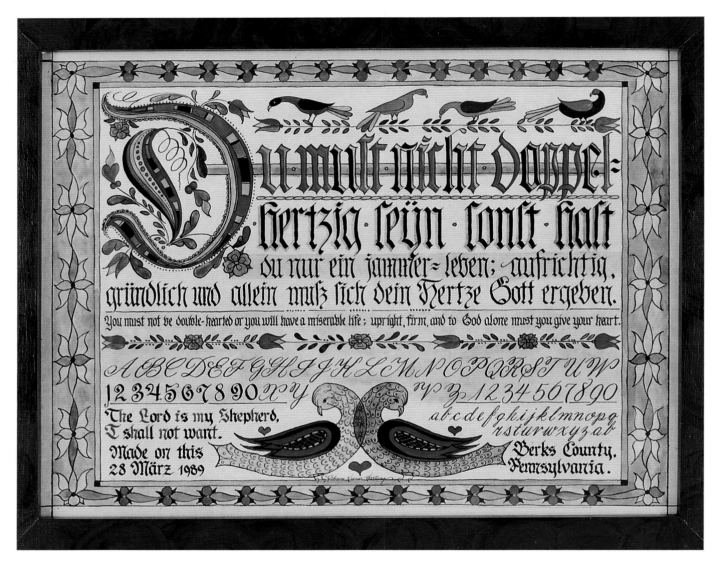

A *Vorschrift* is a writing specimen made by a school-
master for his students to copy as a writing exercise or
a sampler made by a Fraktur artist to show the range
and style of motifs that could be chosen by prospective
clients. The page usually includes upper- and lowercase
letters, numbers, a religious quotation or phrase, and
decorations, or any combination of these.

Tools and Materials

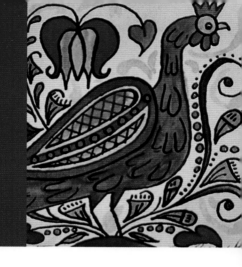

You need a flat work surface, such as a drawing board, desk, or table, and a comfortable chair. The following tools and materials should be available at a local art-supply store, or see the Supplies section at the back of this book.

NIBS AND HOLDERS

Hunt Crowquill pen nibs, size 102 or 107, and holder with a round opening are recommended.

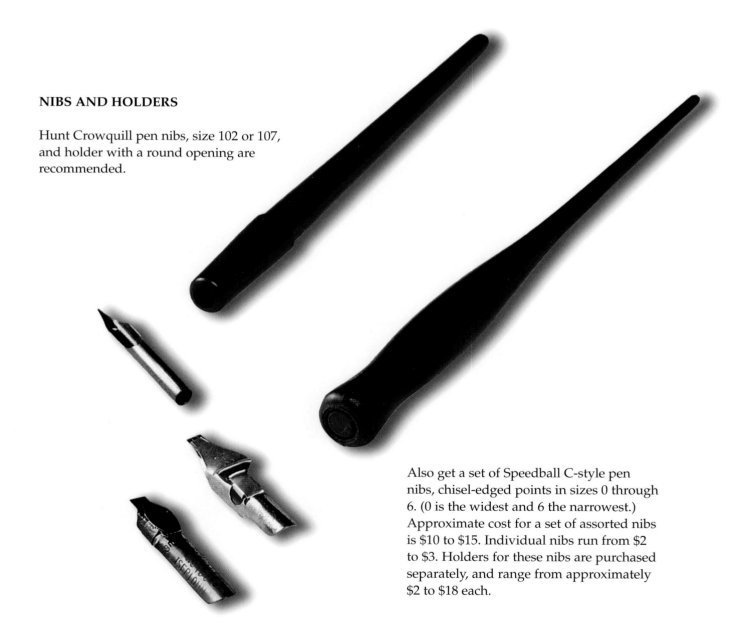

Also get a set of Speedball C-style pen nibs, chisel-edged points in sizes 0 through 6. (0 is the widest and 6 the narrowest.) Approximate cost for a set of assorted nibs is $10 to $15. Individual nibs run from $2 to $3. Holders for these nibs are purchased separately, and range from approximately $2 to $18 each.

Making Natural Quill Pens

Originally, the tool most commonly used for writing and drawing was the natural quill cut with a knife to a point. Steel pen points were not invented until about 1830. Longer, sturdier feathers such as the wing feathers of a goose were preferred. Many people raised their own geese as a source of food for the household, and wing feathers were plentiful.

Today large feathers from peacocks or turkeys are more available than goose feathers. Peacock feathers are more decorative and turkey feathers more utilitarian. You can obtain natural turkey, duck, or goose wing feathers at a farm in your area, purchase them from reenactor suppliers or hunters, or perhaps find them in a field. The easiest quills to use are ones that have been shed naturally and are already dried. If you want to try using freshly pulled feathers, they need to be prepared for use as follows.

Open doors or windows for ventilation during this process, as it creates an unpleasant odor.

Fill a clean container, such as an empty coffee can or small metal pot, with 3 or 4 inches of water. In the water, dissolve a tablespoon of powdered alum, an astringent available at a pharmacy or in the spice section of a supermarket. Bring to a boil on the stove.

You can either remove the feather barbs or leave them on for their decorative value. Put a few of the feathers, quill end down, into the boiling alum water. After about twenty minutes, remove them from the boiling water. This process removes the material from inside the shaft of the quill. Lay the feathers on a paper towel to dry. Use tongs or hot pads to carefully remove the coffee can or metal pot from the stove. Turn off the heat and dispose of the alum water. If you used a cooking pot, wash it well before using it for heating food.

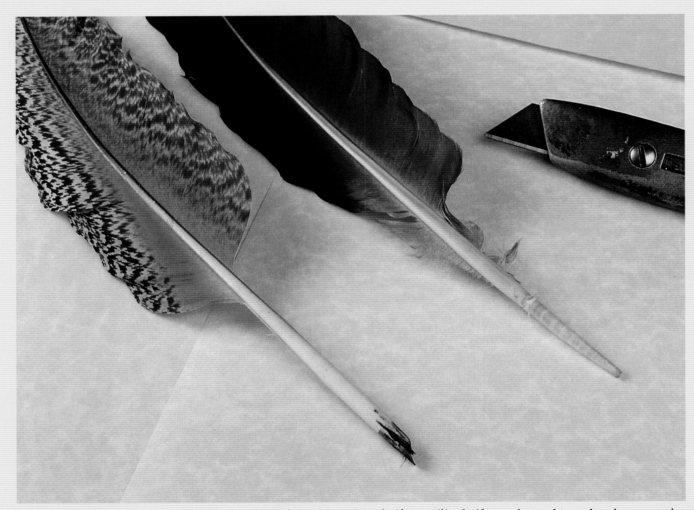

An unsharpened quill and one that has been used for writing. A penknife or utility knife may be used to make a long, angular cut in the shaft of the feather, then again to cut a shorter bit that will become the actual point.

To cure or harden the cleaned quills, lay an inch or so of sand or kitty litter in a metal tray with raised edges, such as a cookie sheet. Insert just the points of the quills into the sand, and put the tray into the oven at 250 degrees F for about thirty minutes. This will dry the clean quills and make them sturdy enough to cut into the shape needed to apply ink to paper.

Alternatively, you can tie a bunch of feathers together and hang them in a dry place to cure naturally for a year or two.

For ordinary use, prepare the nib of the dried quill for writing in the following manner: Hold the quill shaft in your left hand, and with a sharp blade like a utility knife, about an inch back from the nib make a quick slanted cut toward the end, cutting away from your body. Approximately in the center of this cut start a second, more slanted cut. This should produce a pointed end on the nib.

Place the pointed nib upside down on a sturdy surface, and make another cut that divides the sharpened point. This is important so that when gentle pressure is applied, the sides of the point will split to produce the thicker parts of the letters. Remove any "strings" left on the quill after cutting by scraping or paring the edges with a blade or smoothing with a very fine piece of sandpaper. This is a delicate process, and it requires a lot of practice to get good results.

Fill this nib by the same process as the steel Hunt Crowquill, by rubbing it against the edge of an ink-filled brush held in your other hand. Dipping the nib into an ink bottle picks up too much ink, which pools and smears when applied to the paper.

After a certain amount of use the natural quill will soften. When you are aware that this is happening, just recut the nib and continue lettering. It is helpful to prepare several quills at a time so that you will always have a fresh one available.

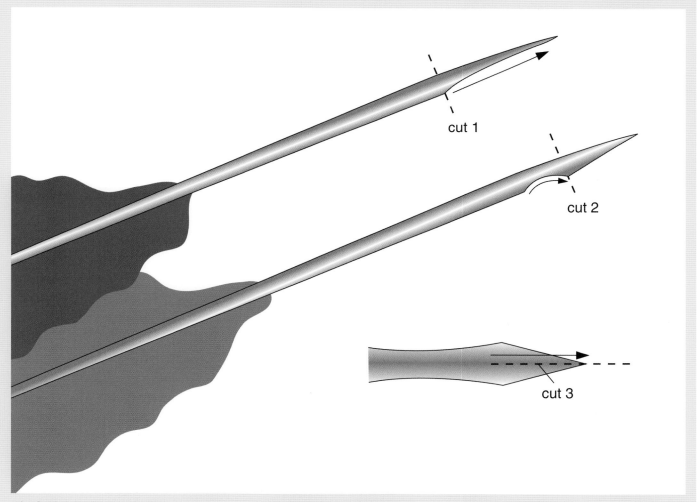

The feather barbs on a quill have been removed to make it more comfortable to hold. Also shows the first, second, and third cuts to form the writing point.

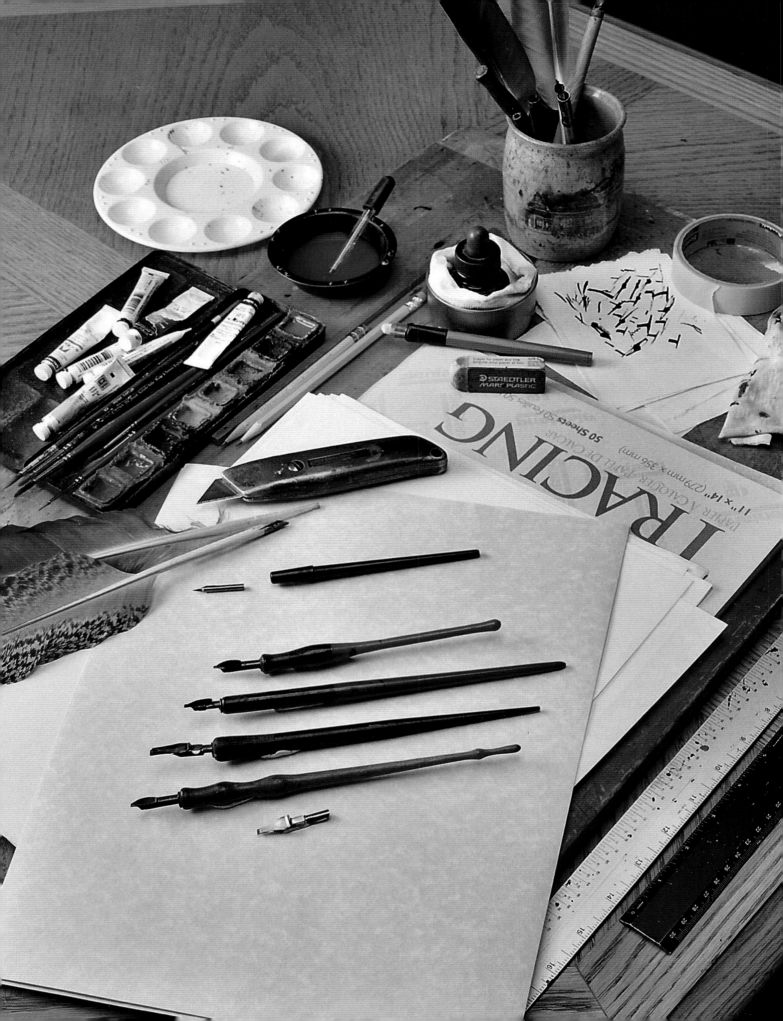

BLACK INK

F&W and Pelikan are recommended. Do not use India ink. It is too thick for pen lettering. Approximate cost for a 1-ounce bottle $5 to $6.

WATERCOLORS.

Use any brand available in .25-ounce tubes, in these five basic colors:

- Cadmium Red (dark)
- Cadmium Yellow (deep)
- Hookers Green (deep)
- Prussian Blue
- Raw Umber

My paint box is a conventional one that has removable color pans. When I use up an original color, I clean the pan and reuse it for a custom-mixed color. If you want your paints to be portable, it's easy and inexpensive to use a plastic egg carton and close the lid when the paints are not in use. Approximate cost for .25-ounce tube $4 to $6.

WHITE WATERCOLOR MIXING PALETTE

WATERCOLOR BRUSHES

Buy pointed brushes, numbers 2 and 4. Approximate cost $3 to $13.

NUMBER 2 LEAD PENCILS

ERASER

MASKING TAPE

Use the tape to attach the paper to the drawing board so the paper doesn't move while you are working.

WOOD OR METAL RULER

Make sure it has sixteenths-of-an-inch measurements.

UTILITY OR CRAFT KNIFE

SMALL DISH OR JAR FOR WATER

RAG

Use this as a pen wiper. An old undershirt works great!

APRON OR SHIRT

To protect your clothing.

COMPASS

SCRATCH PAPER

To test ink flow of the pen while working.

TRACING PAPER

Any size is fine. Approximate cost for an 11 x 14 tablet with fifty sheets $7 to $9.

WHITE OR ANTIQUE-COLOR CALLIGRAPHY PAPER

It is purely a matter of personal preference whether you use white or antique-color paper. One thing to consider is that your colors will look slightly different when applied to white paper than on antique-color paper. Both types are sold in tablets. Buy 9 x 12 or 11 x 14 inches. Approximate cost $12 to $15.

Antiquing Your Paper

Some people like to give an antique appearance to their Frakturs by staining the white paper with a tea or diluted coffee. Tea will give a grayish color to the paper, and coffee a brownish color.

If you would like to see the effects you can make, experiment with the following mixtures: Put a teaspoon of instant coffee crystals in a shallow dish, and add $1/4$ cup of water. Stir until the crystals dissolve. You can adjust the depth of color by adding more coffee or water.

The tea mixture is prepared by steeping several tea bags for a long time in hot water. (This is not the "classical" method, but one that I developed for speed and effect.) Wipe the stain on the paper with a sponge or paper towel. Wetting the paper will cause it to wrinkle, so flatten it with a warm, dry iron. This ironing technique works best when the paper is only slightly damp.

The process can create interesting effects, but because tea and coffee add acid to an already acidic paper, this will cause the piece to deteriorate much faster than when using untreated paper. Therefore, this manner of staining is not recommended for any Fraktur that you want to become an heirloom.

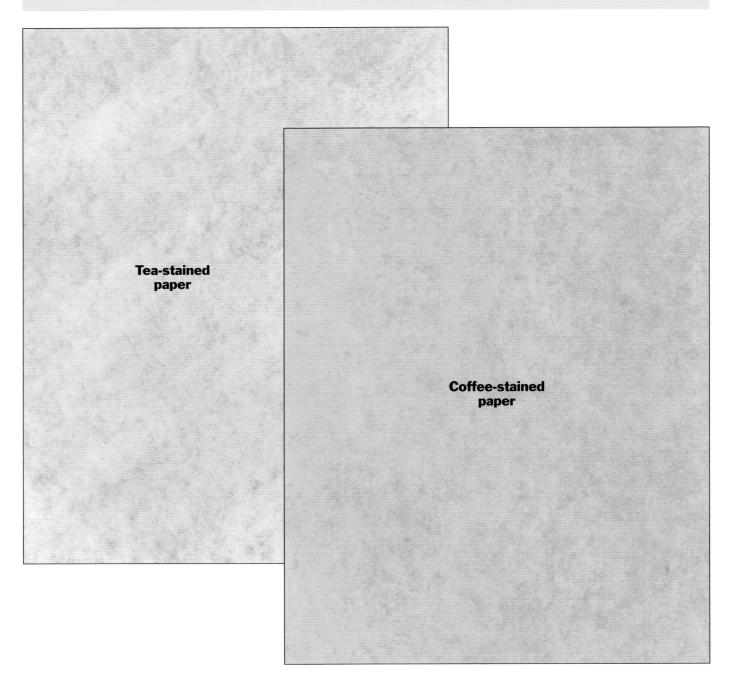

Tea-stained paper

Coffee-stained paper

Basic Skills

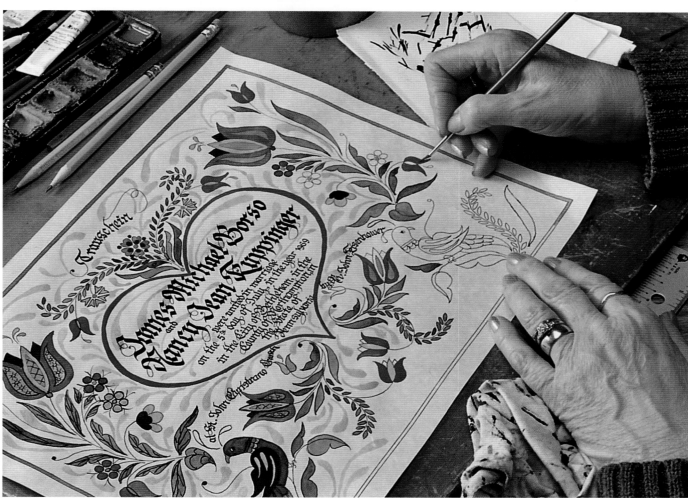

Creating a Fraktur is subject only to tradition and the personal expression of its maker. A Fraktur is a two-dimensional representation, and thus forms inspired by customs, culture, and nature are transformed into stylized, decorative designs. Perspective was difficult for untrained craftspersons, so they tended to avoid it and instead create flat representations without shading.

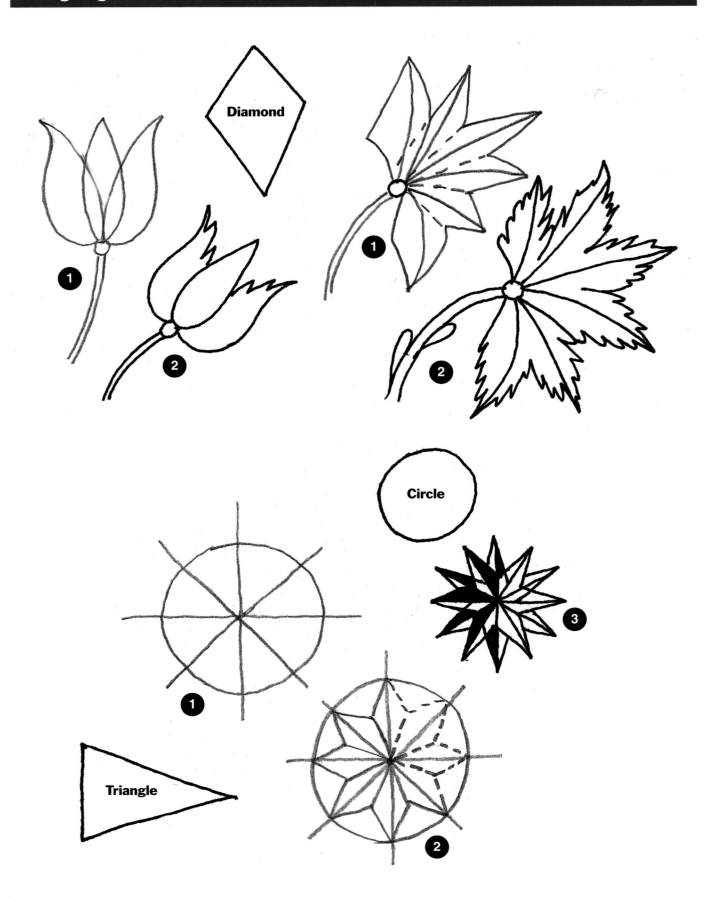

Diamond

Circle

Triangle

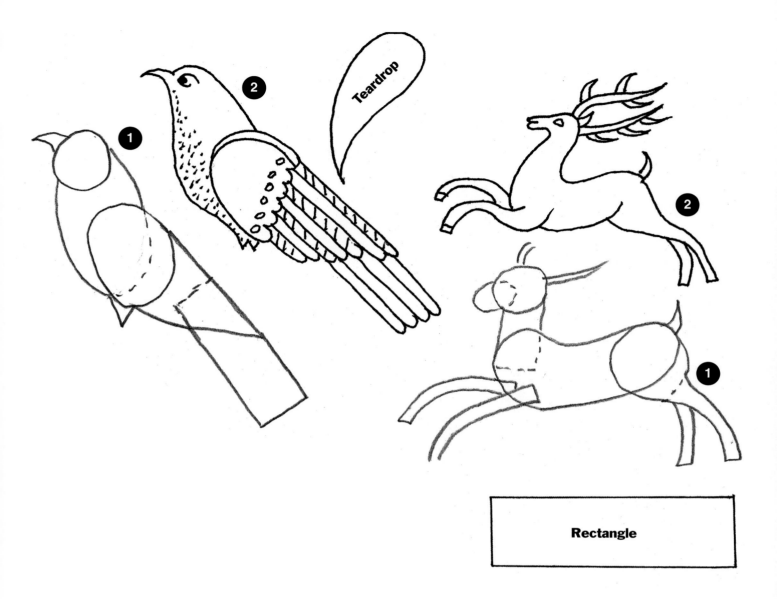

In the traditional Fraktur, each element of the design is given its own space without overlapping. The design as a whole is usually bisymmetrical, or formal, with one half being a mirror image of the other. Some examples of asymmetrical, or informal, design arrangement can be seen on small pieces like bookplates or bookmarks, however. One element necessary to good design is that each motif is shown in odd numbers. For example, a leaf or flower is shown one, three, five, or seven times rather than an even number of times, which tends to create a monotonous feel.

Early craftsmen used few colors, as their inks, colors, and paints were made from materials such as grasses, berries, and insects. Their colors included several shades of red, yellow, green, and sometimes blue, as well as gray or brown. In time, oranges, purples, and pinks were also used. Blue had to be made from imported substances and was very expensive, so it was used sparingly, if at all. After 1840, the Victorian era produced more vivid bright oranges, a purple crimson, and yellow-greens.

Some scholars, but not all, believe that the motifs commonly found in Pennsylvania Dutch folk art originally had symbolic meanings rooted in Protestant religious beliefs. Symbols used on Frakturs developed more secular and personal meanings. Choices of which symbols to use as motifs on a birth certificate, for instance, depended on the preferences of the parents for whom it was made. On a partially printed certificate, the motifs were already there, but individuality could be expressed by coloring these forms in brightly decorative ways and by using unique styles of lettering.

The motifs that have been used as decoration on Pennsylvania Dutch Fraktur are as follows, listed in general groups by frequency of use: flowers and fruits; birds and animals; geometric and abstract designs; architectural elements; religious symbols and themes; and secular elements and themes.

FLOWERS AND FRUITS

The tulip is sometimes called the lily of the field, representing man's search for God and purity. Three tulips may symbolize the Trinity (God, Jesus, and the Holy Spirit) or life, love, and immortality. Several tulips on one stem is called the tree of life. If there are five tulips, this means good luck. Seven tulips refer to guardian angels. Twelve tulips suggest Christ's disciples. Other flowers frequently seen are fuchsia, carnation, rose, lily of the valley, and forget-me-not.

Fruits (and vegetables) typically used are the pomegranate, grapes, strawberries, apples, and corn, and these may be presented in cornucopias or bowls.

Vines and leaves may fill in spaces, and trees were added in the nineteenth century.

BIRDS AND ANIMALS

These forms are treated creatively and sometimes originate from heraldry design. Typically used are the distelfink, a goldfinch, which means good luck; parrot, once native to North Carolina; dove, a symbol of the Holy Spirit, the human spirit, or love; peacock, a symbol of Christ's resurrection (when looking at its tail, it means rebirth); pelican, a symbol of self-sacrifice; crowned swan, the bird of heaven; eagle, a symbol of freedom with a single head (a double-headed eagle was used in heraldry); turtle, a symbol of a believer seeking his or her savior; and unicorn, guardian of maidenhood. Other common bird and animal motifs are deer, roosters, lions, horses, robins, lovebirds, scarlet tanagers, ducks, hummingbirds, owls, butterflies, dogs, cats, snakes, lambs, crocodiles and whales.

STARS

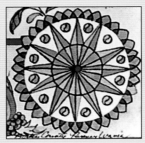

Stars with four points typically mean a stern warning. Five or seven points indicate cheerfulness and happiness. Six points is considered the true star, but it also may be a warning sign. Eight points may be considered similar in meaning to stars with four or six points.

HEARTS

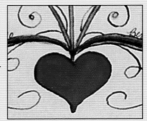

The heart symbolizes the heart of God, the source of all love and hope. A heart inside another heart is the heart of man. The Pennsylvania Dutch Fraktur heart is called a flat heart; it is formed by two circles and is very round and heavy looking.

It is easiest to begin with a small Fraktur drawing to practice the skills you are learning. You do not have to deal with perspective, and most of the motifs can be drawn using geometric forms. When you feel comfortable with the small drawings, gradually work up to an 8x10-inch composition into which you can put a few words. This could be your own birth Fraktur, so you can begin with letters and numbers that are familiar to you.

In class, I tell the story of an itinerant Frakturer who visited a farm where a child had recently been born. When he asked what designs should be used for the Fraktur, the farmer's wife remembered that each morning a red cardinal visited her at the kitchen window, and she wanted that cardinal to be included in the design. Think of things that are meaningful to you, and include them in your design. There are many ideas for

FISH

The fish is a symbol of Christ the Savior. It also signifies plenty.

CROWN

The crown is a symbol of heaven. It can also refer to the head of a household.

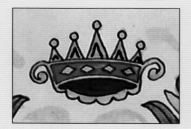

ANGELS

Angels signify piety. Typical poses are angels with only heads and wings, standing, or flying. Sometimes the angel holds a book, bird, or palm branch.

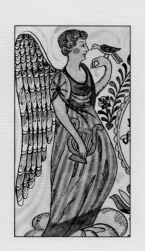

PORTRAITS

Full-figure military or civilian subjects are typical and symbolize patriotism. People were typically rendered in a primitive style, as Fraktur artists were not trained to draw the realistic human figure.

HOUSES

Houses follow the style of any typical Pennsylvania house of the time, and they include detail of doors and windows. Barns, churches, or schoolhouses may be added.

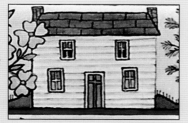

CLIPPER SHIPS

Clipper ships are symbols of travel from the Old World to the New World. They also represent commerce.

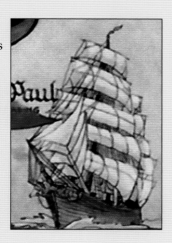

you to start with in the Patterns section of the book, until your own ideas start flowing.

Over the long term, build your own "library" of interesting motifs by sketching forms on tracing paper to save until you find a place to use them in a composition. I have assembled a large box full of these small bits of inspiration around which a composition can grow, and I refer to them often. If you have difficulty thinking of something, you can also refer to the books listed in the Bibliography or visit your historical society or a local museum to see the Frakturs in their collections. Libraries may also have some volumes, especially those out of print, available in their reference departments.

There are very few rules involved in creating a Fraktur design. Experiment with ideas, patterns, and colors—and have fun!

To create authentic-looking Fraktur, mix the five basic colors as follows to achieve variations for your palette. Start with a small amount of the lighter color, and add only a small amount of the darker color until you achieve the shade you want. Thin the pure colors with water to make them more workable; thinning will also help you achieve the shade you desire. Application of color varies from transparent to muted or soft to bright and glossy. Dilute the paint with water to achieve the desired shades.

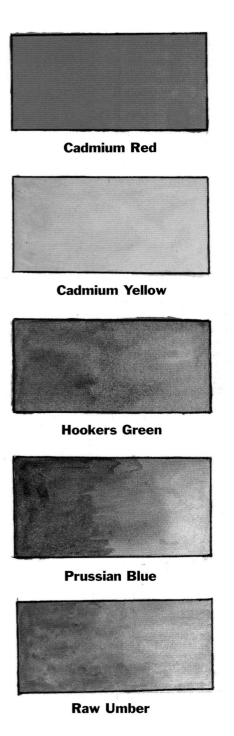

Cadmium Red

Cadmium Yellow

Hookers Green

Prussian Blue

Raw Umber

Basic colors on white paper

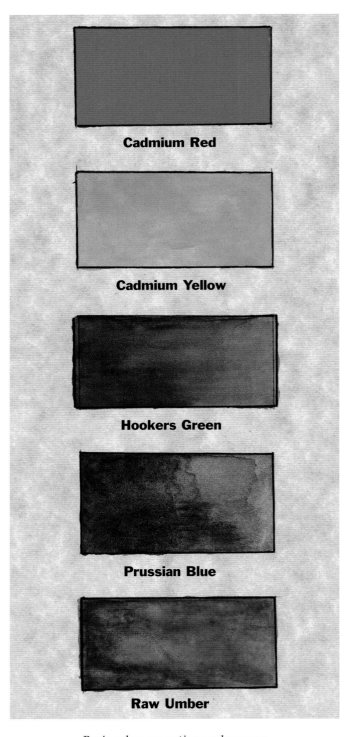

Cadmium Red

Cadmium Yellow

Hookers Green

Prussian Blue

Raw Umber

Basic colors on antique-color paper

Mustard Yellow. Add raw umber to clear yellow.

Sky Blue. Use pure blue for a deep sky blue.

Turquoise. Add a touch of green to the blue.

Clear Red. Use pure red for this brilliant hue.

Brick Red. Add raw umber to clear red.

Dark Red. Add small amounts of green or blue to clear red; shades can vary from maroon to brown.

Light Muted Mossy Green. Add yellow to dark green.

Dark Muted Mossy Green. Use pure green or add some umber or red to produce varying shades.

Orange. Add red to clear yellow.

Purple. Add blue to clear red.

White. Leave areas of the paper unpainted.

Black. Use ink.

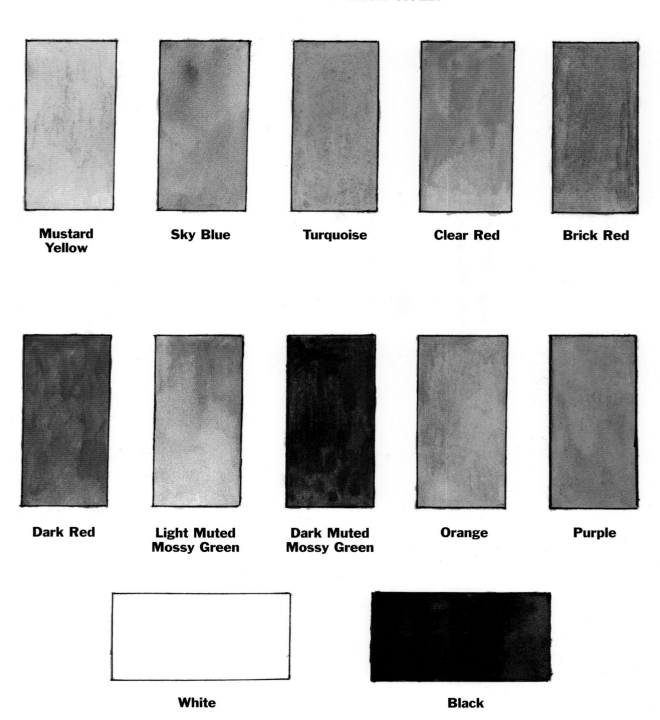

Mustard Yellow **Sky Blue** **Turquoise** **Clear Red** **Brick Red**

Dark Red **Light Muted Mossy Green** **Dark Muted Mossy Green** **Orange** **Purple**

White **Black**

Mixed colors on white paper

Colors appear different on white and antique-color papers. Experiment to find your own preferences. Try to mix enough of any color at one time to complete your piece. If the paint dries between work sessions, add a drop of water to the dried paint and let it stand for a few minutes to soften.

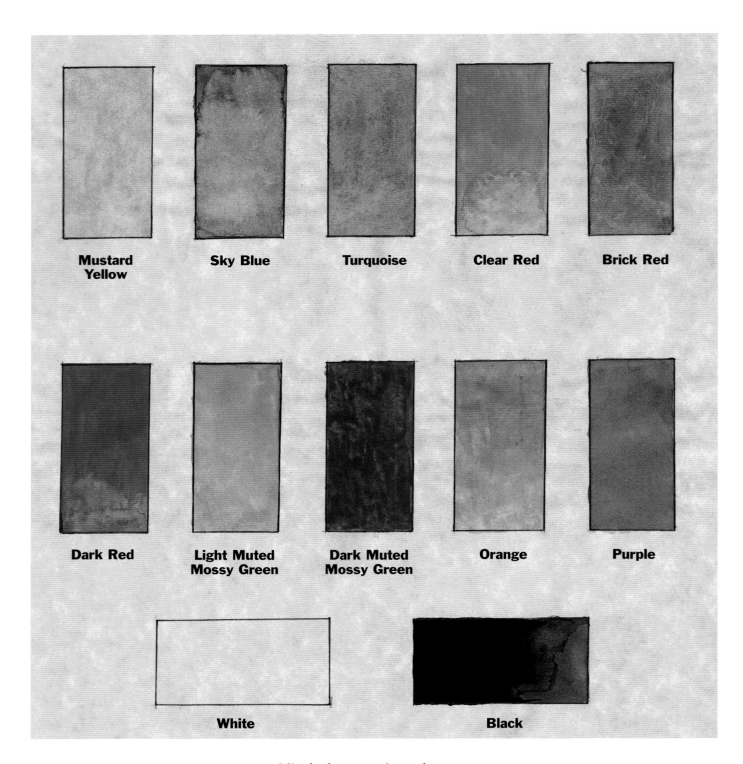

Mustard Yellow **Sky Blue** **Turquoise** **Clear Red** **Brick Red**

Dark Red **Light Muted Mossy Green** **Dark Muted Mossy Green** **Orange** **Purple**

White **Black**

Mixed colors on antique-color paper

You need two types of pens for lettering your Fraktur. The Hunt Crowquill has a very thin nib, or pen point, and is used for outlining your color areas and making elaborate flourishes on your basic letter forms, if desired. The Speedball C chisel-edged nib is the basic tool for making the letters in the words. Before beginning to letter your Fraktur, it's important to get plenty of practice until you feel comfortable with both kinds of pens.

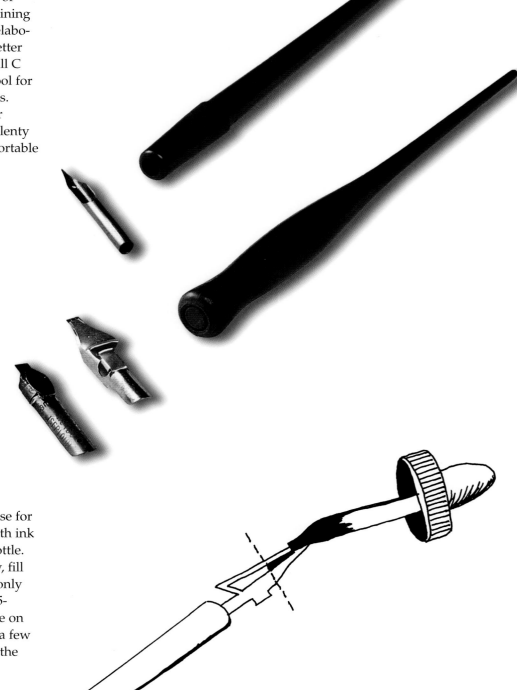

First determine the size of the Speedball C nib you want to use for your letters, and fill the nib with ink using the eyedropper in the bottle. For the best control of ink flow, fill the reservoir of the pen point only halfway. Place the point at a 45-degree angle to the writing line on your scratch paper, and make a few practice strokes to ensure that the ink is flowing smoothly.

After you feel comfortable working with the Speedball pen for the basic letter forms, it is time to try the Hunt Crowquill for the thin flourishes. You also will use this pen later for outlining.

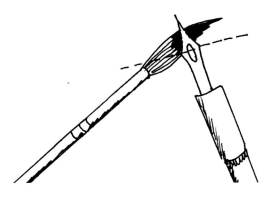

Apply the ink to this steel quill point by wiping it against the edge of a watercolor brush dipped in ink.

There are some special techniques you need to master with this pen. A common error is to apply too much pressure on the pen point. The point is very flexible, and too much pressure could result in a blob of ink where you want a fine line to be.

A good practice to follow for both types of pens is to keep a scrap of paper at hand to use for a few practice strokes before applying the pen to your work. If you continue to get spots of ink, make sure the point is not over-loaded with ink. You may need to rinse the point in water, dry it, and start again.

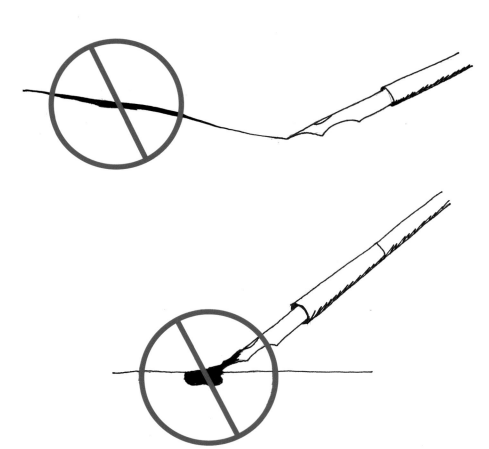

Uneven ink flow may be caused by paper fibers stuck in the point. To remedy this problem, draw the point over the paper with no pressure at all, in a straight line, from left to right or top to bottom (or for left-handers, right to left or bottom to top). This will dislodge any fibers that may be stuck in the point. Rinse and wipe the point carefully, and start again. As you work, it will be necessary to fill and wipe the point often.

Thin steel points are very fragile. At any time, a point may crack or break without apparent notice; you will notice, however, that the point is not functioning properly. First try freeing it of fibers and rinsing it, and if this doesn't work, discard the point and use a new one. Avoid working in an area where the ink is still wet, which can result in a smear. Also be sure the paint is dry before outlining so that the ink doesn't run into it.

On the opposite page are letters, lines, spaces, and directional arrows to help you learn letter forms. Use tracing paper placed over the page to practice the letter forms until you feel comfortable with the pen. I designed the alphabet to be a bridge between the severe old Black Letter forms and newer letter forms that are easier to read. Study it to find the order in which the pen strokes are made to form a letter. The upper-left top line shows the 45-degree angle that should be used to place the C pen point on the writing line of the paper. The first line of letters uses numbers to indicate the order in which you should make the pen strokes and arrows to show the directions in which the strokes are made—top to bottom and left to right.

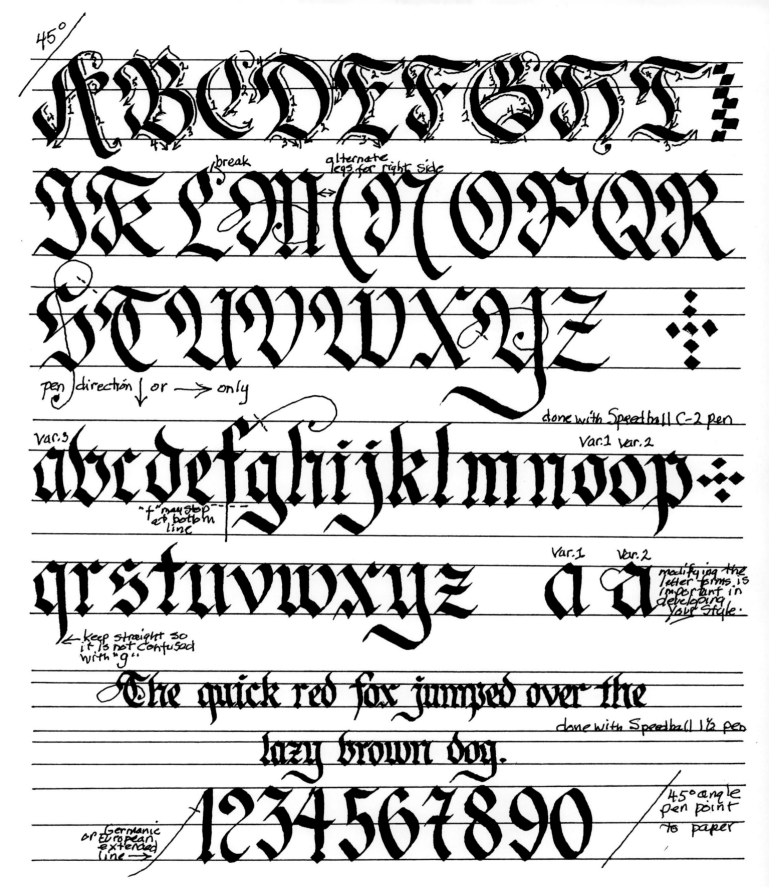

45°

break

alternate legs for right side

pen direction ↓ or → only

done with Speedball C-2 pen

Var.3

Var.1 Var.2

"t" may stop at bottom line

Var.1 Var.2

modifying the letter forms is important in developing your style.

← keep straight so it is not confused with "g"

The quick red fox jumped over the lazy brown dog.

done with Speedball 1½ pen

1234567890

45° angle pen point to paper

or Germanic or European extended line →

At the right-hand side of the chart are marks showing the pen width used for that size letter. Adjust these to make the size letter appropriate on your Fraktur. For example, a smaller point size is needed for the "quick red fox" quotation than is needed for the bigger alphabet letters. Some variations are also noted in the lowercase alphabet, with different flourishes, ascending lines, or descending lines. Also notice the spacing of the letters on the quotation line to make them fit together well.

1"

Above are straight guidelines for lettering practice. On the opposite page are straight guidelines and 45-degree-angle lines for lettering practice.

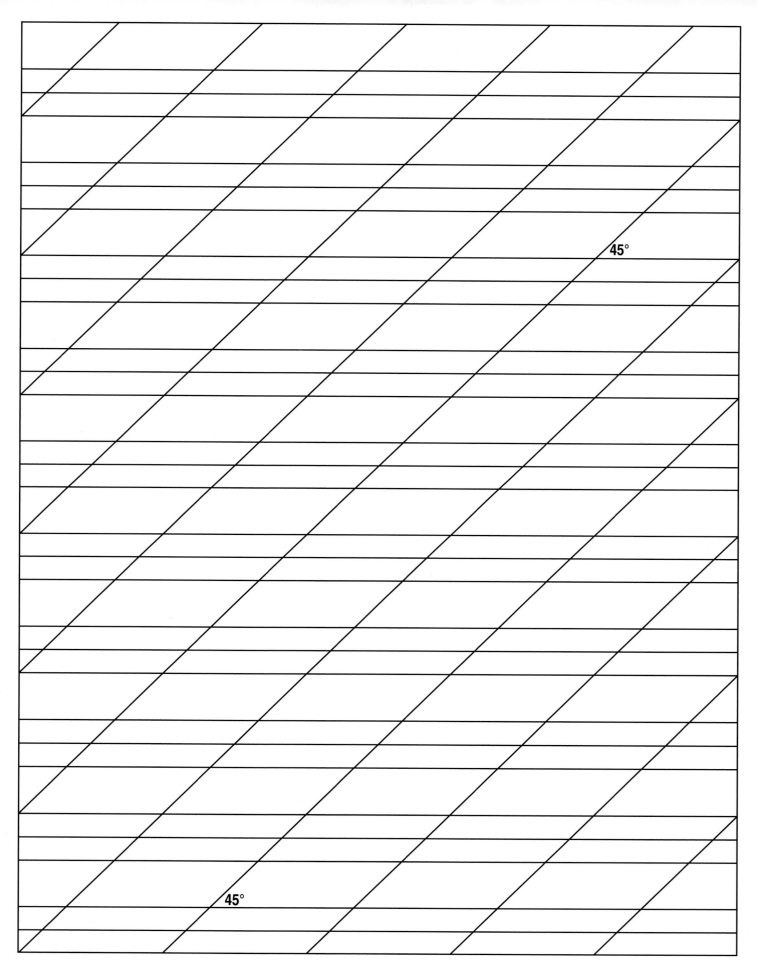

45°

45°

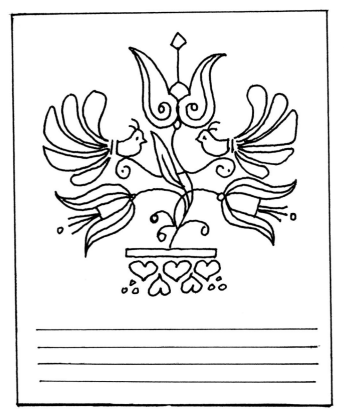

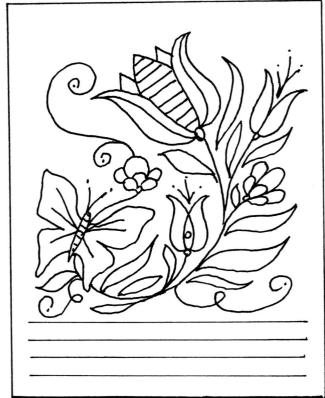

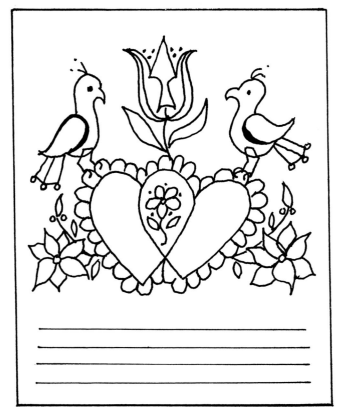

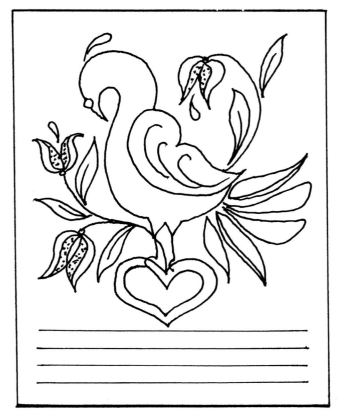

Here are some patterns for practice. The formal, or symmetrical, designs are on the left and the informal, or asymmetrical, designs are on the right.

The lines below each design are provided for you to practice your lettering by putting a sheet of tracing paper over the page.

38

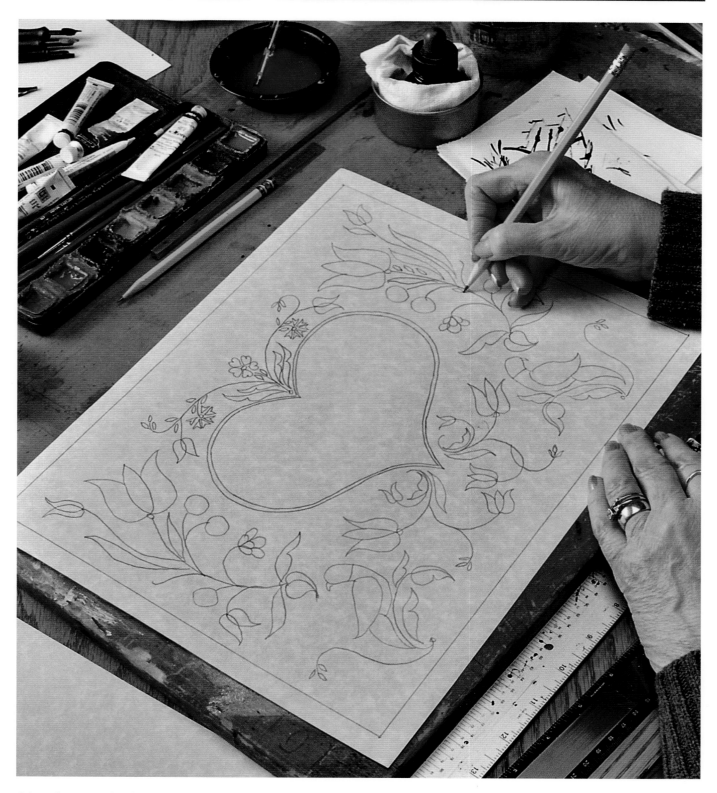

After choosing the design and paper, draw the images in pencil. Draw guidelines for placing the lines of lettering, and pencil the letters in place lightly to be sure they will fit in the space available. You may have to adjust the width or height of the letters to make them fit. Refer to the sample alphabet on page 35 for ideas about the appropriate width of each letter. Change motifs around or adjust their size as needed.

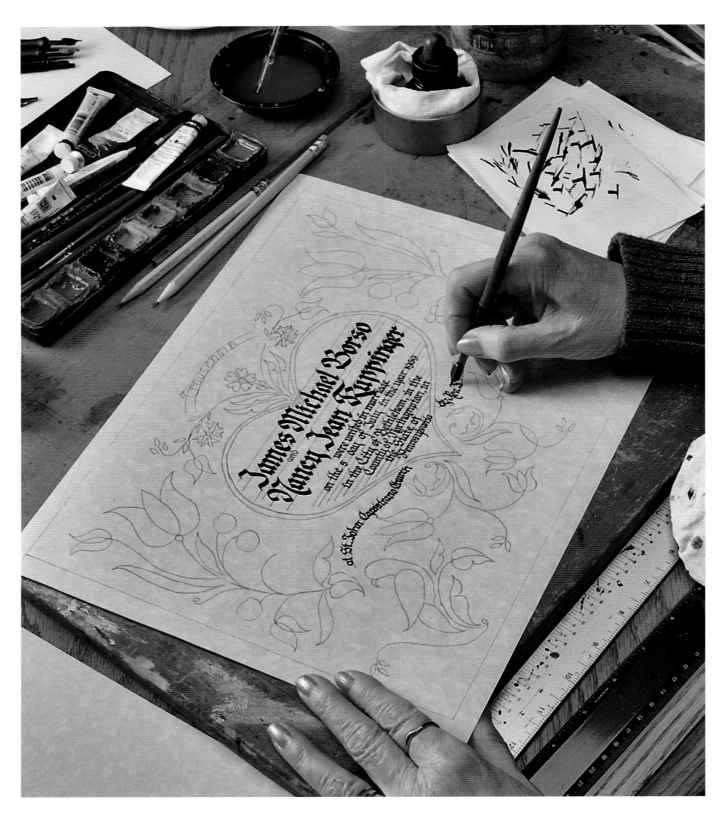

When you are satisfied with placement, ink in the letters. If you are right-handed, work top to bottom and left to right. If you are left-handed, work bottom to top and right to left, and you will need to place the paper almost sideways to achieve the 45-degree angle of the pen to the paper. The most likely place to make a mistake is misspelling a word. By lettering first, you waste less time than if you had colored the entire design and then made a spelling mistake in lettering and had to start over again. This is not erasable ink!

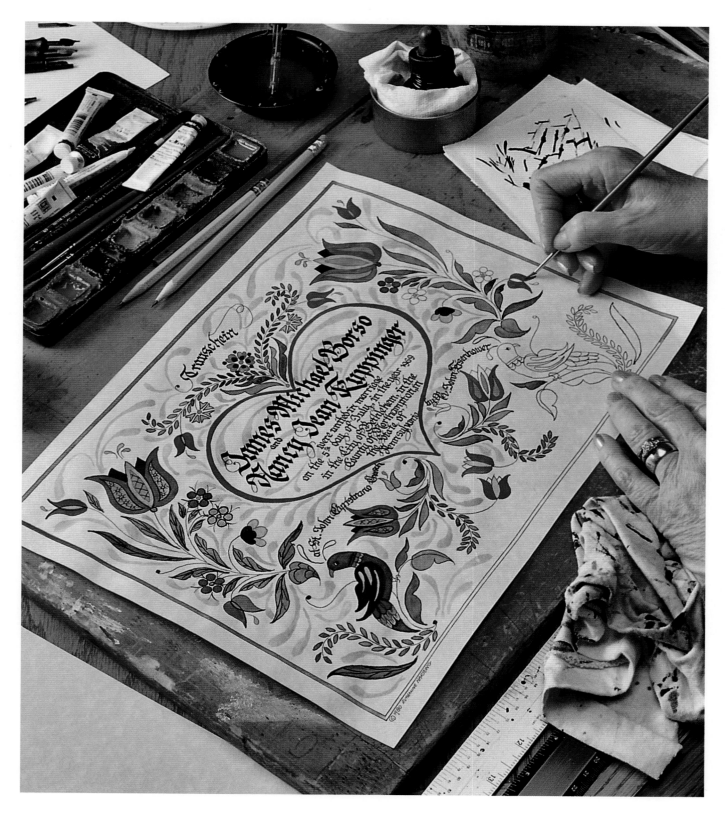

After the lettering is completed, relax and consider the colors you want to use. You may want to fill in all the green areas, then the red, and so on, or complete one motif at a time. There is no right or wrong way. Do what you are most comfortable with. If you are using waterproof ink, which I prefer, you can draw in black ink over your pencil lines first to outline the color areas. Be sure the ink is dry before filling in with watercolor.

Apply watercolor with the number 2 brush for smaller areas and the number 4 brush for larger areas. Again, right-handers should work top to bottom and left to right and left-handers bottom to top and right to left. This lessens the possibility of putting your hand in wet ink or paint. If this happens, you will smear your Fraktur and have to start over again.

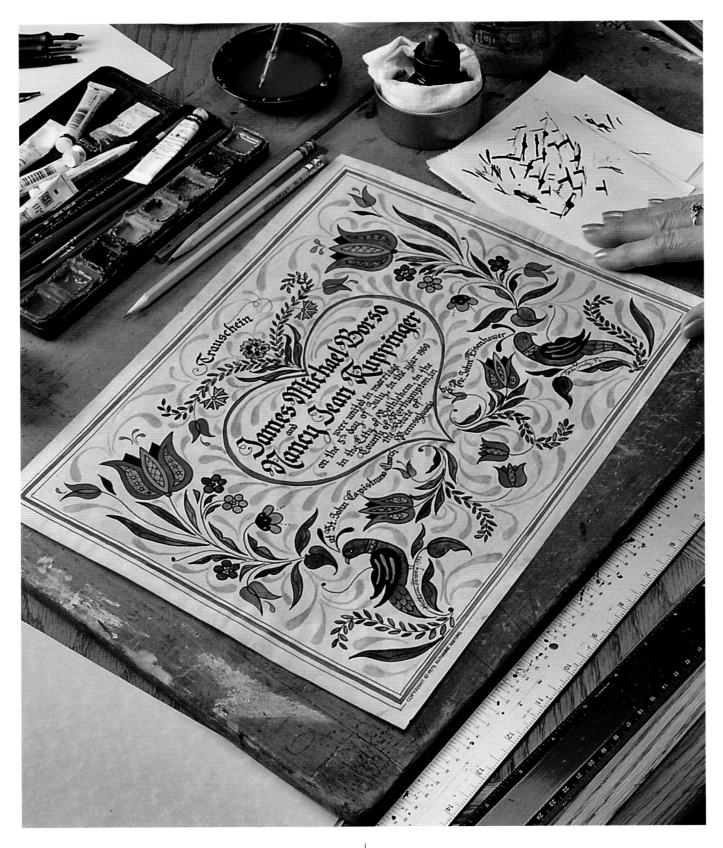

After the ink and watercolor have dried, erase all the pencil guidelines. If you are using ink that is not waterproof, this is also the time to outline the color areas.

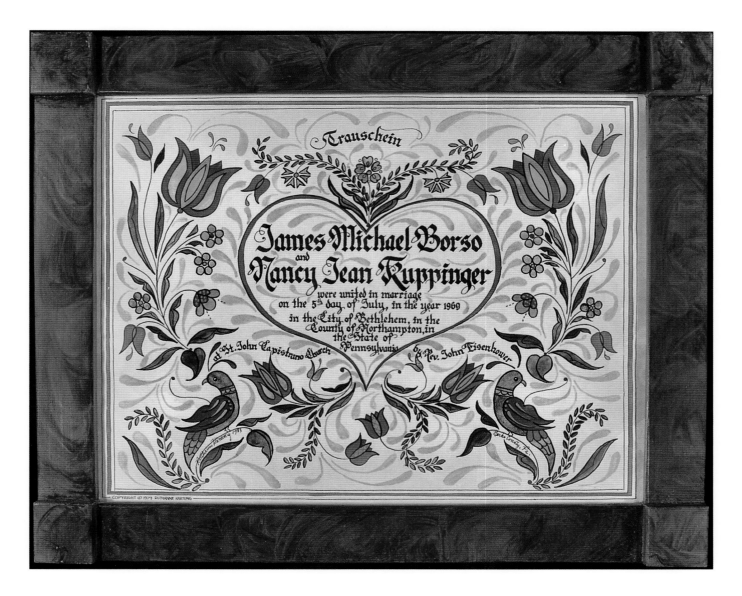

There are several possible styles of frames you can use to complement your Fraktur. Matting was not traditionally done, because matting material was not generally available. The corner block style was developed to hide the less-than-expert miter cuts done by folks who made their own frames at home. More expert frame makers, who could create frames with smooth miters, did not use the corner block style. Corner blocks are popular for Frakturs, however, because they are appropriate to the time period when this folk art was first done in America.

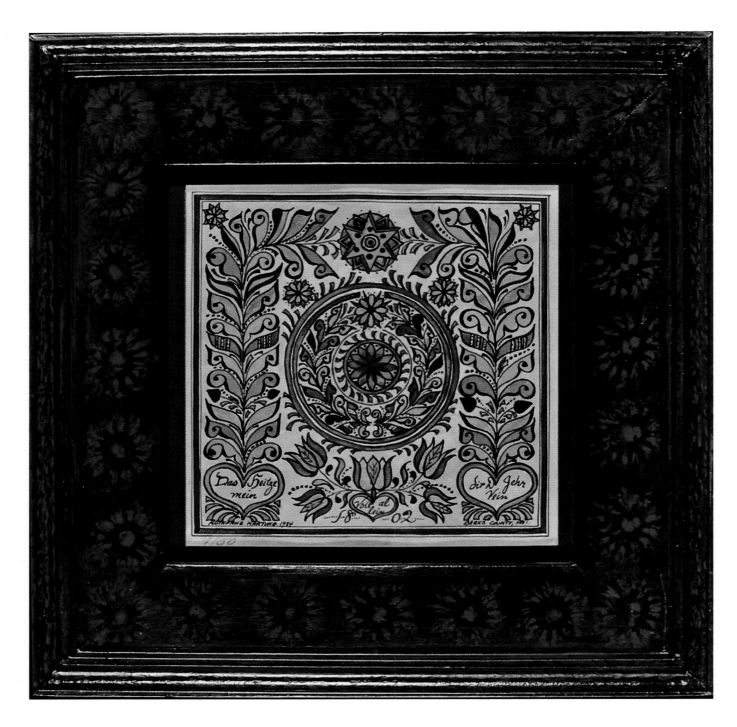

Finishes on frames were usually painted. The painted base coat could also be false grained by applying another color paint over the base color, making the frame quite decorative. You can find many more ideas by consulting a book on framing techniques, keeping in mind the appropriate time period your work represents.

Small Fraktur

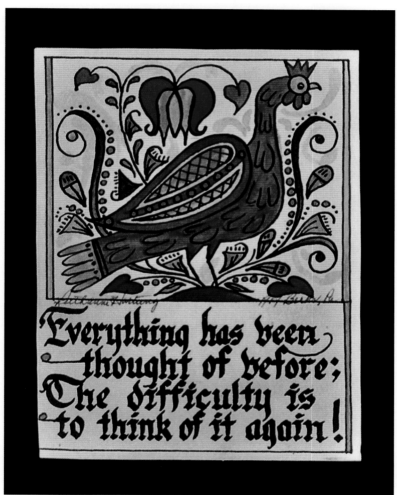

The first project is a small Fraktur that you can complete quickly and become familiar with the steps. These steps are basically the same for all compositions, both large and small. Using coffee-stained paper will give the effect you see in the illustration.

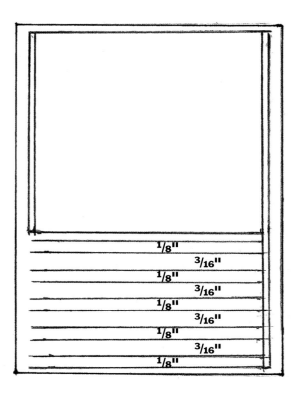

Outline the edges of the project, in this case 2³/₄ x 3³/₄ inches. Mark off the border, ¹/₁₆ inch at top and bottom and ¹/₈ inch on the sides, with another line ¹/₁₆ inch inside that as shown. Also draw guidelines for lettering the quotation, ³/₁₆ inch apart where the bodies of the letters will go, and ¹/₈ inch above and below those lines for the parts of letters that extend up or down.

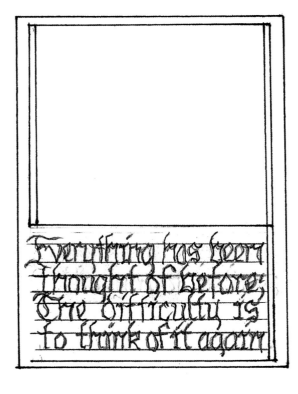

Pencil in the letters for the quotation carefully. There should be enough room that the ascending lines don't conflict with the descending lines of the letters above. Redraw the letters until they all fit well. Ink in the border lines at the top, bottom, and sides.

With a pencil, sketch the drawing in the top part of the design area. In this case, tracing saves time, but freehand drawing will give you experience in how to fill the space well, and you might want to change parts of the design to your own motif ideas.

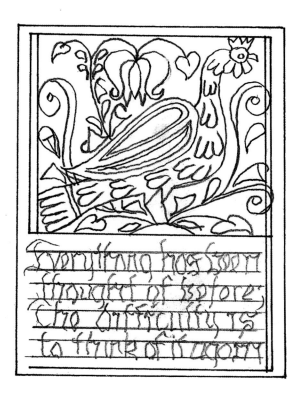

Go over the pencil lines of the design with the Hunt Crowquill pen and waterproof ink, adding any small details. It is difficult to draw the exact same thing twice, so change parts to suit you. Adding small details like lines or dots makes the drawing more interesting. Also ink in the letters using the Speed-ball C4 or C5 nib. Then add the flourishes to letters with the Hunt Crowquill nib. Put the piece aside so that the ink can dry.

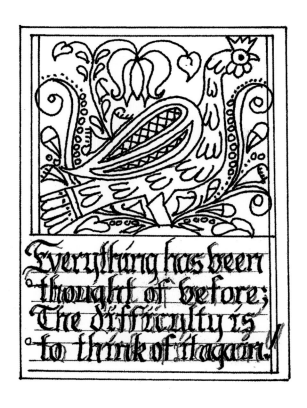

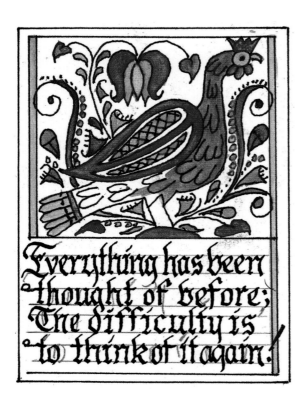

When the ink has dried, use the number 2 water-color brush to apply the colors. Start with the lighter shades, and apply two or more coats until you achieve the desired effect. When working with watercolor, the general rule is to work from light colors to darker colors. This is also helpful if you decide to change colors during the process, as it is easier to put a darker color over a lighter one. Putting a lighter color over a darker color is not usually successful.

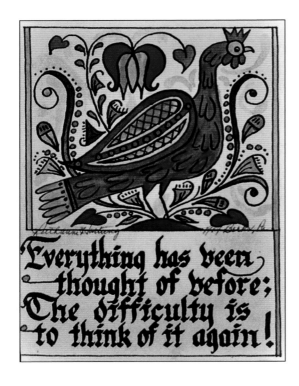

When the watercolors have dried, complete the project by carefully erasing any remaining pencil lines. I like to use a very diluted yellow gold to put little teardrop shapes in areas where they will fit. Adding the teardrops is just a matter of personal taste, and they are not outlined.

Your project is now complete! You can mount it on a larger piece of background paper and frame it, or laminate it to use as a bookmark or a special gift enclosed in a card to a friend. Sign and date your work.

Birth Certificate
(Geburtschein)

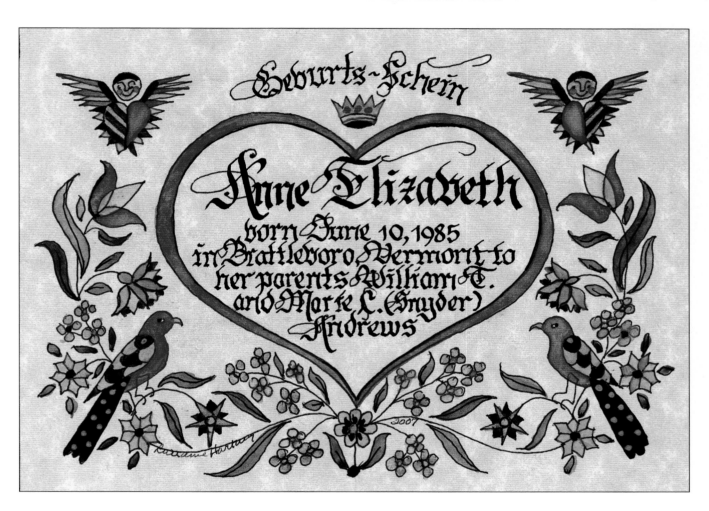

This project has a symmetrical, or formal, design. This means that one half of the design area is a mirror image of the other. The project is 5 x 7 inches.

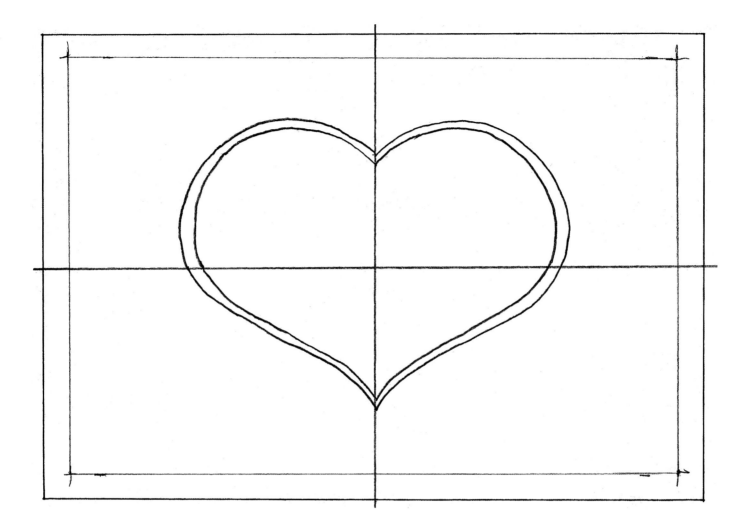

Begin by dividing the design area in half both vertically and horizontally. This determines the center of the work area and provides reference lines for measuring lines for lettering. Also mark off a margin $1/4$ to $3/8$ inch from the edge of the paper on all sides. This is the part that will be covered by a mat or frame, so you don't want your design motifs too close to the edge of the paper. Draw these lines lightly, as they will eventually be erased. Then draw the heart that will enclose the birth information.

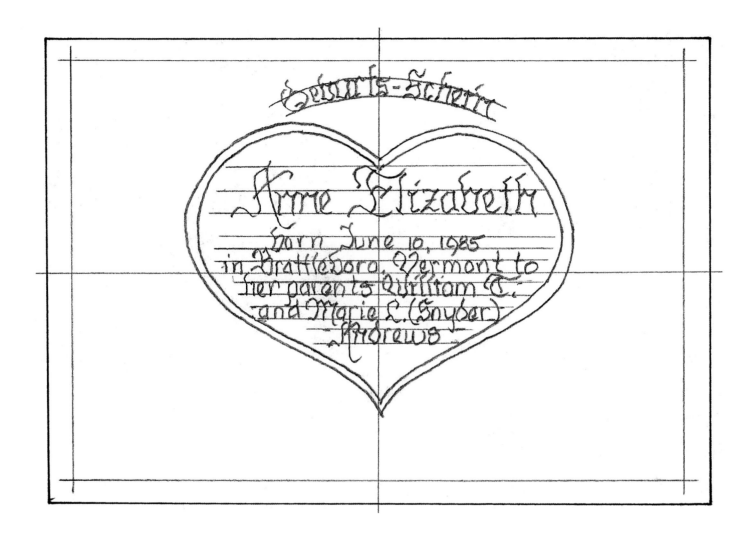

Press lightly on the pencil as you draw the guidelines for lettering. Try not to make indentations on the paper, as they will show when the pencil lines are erased. Lightly pencil inside the guidelines the child's name, birth date, place of birth, and parents' names. If all the letters don't fit in the space, you can redraw the heart shape a little larger.

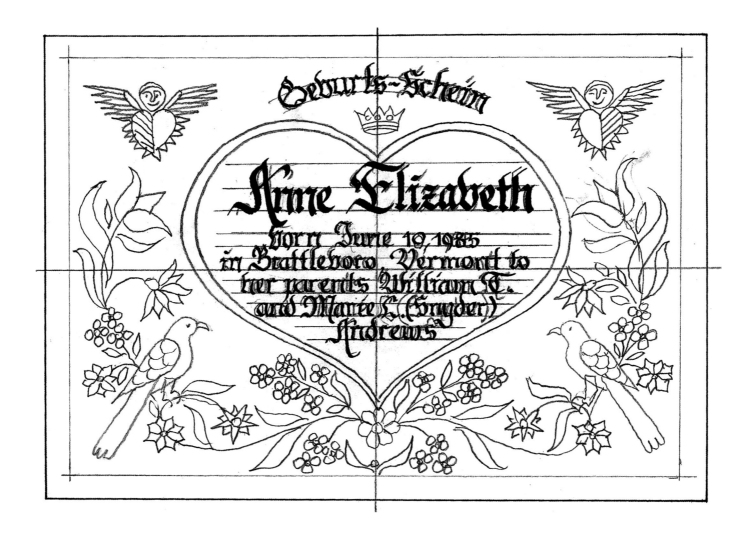

When you are satisfied that everything fits well, ink in the name with a Speedball C1 pen nib. Use a smaller nib, perhaps a C5, for the date, place, and parents' names. Do not ink the heart lines until you are sure all the words fit. Before proceeding, put the piece aside until the ink dries.

When the ink is dry, it's time to draw the design. Use tracing paper to transfer the design to your paper. If you have a light box, you can trace directly from the project drawing, but drawing freehand is good practice if you want to try.

Notice that mirror image has some room for loose interpretation. The original Frakturs were hand-drawn by untrained artists, and everything did not match up perfectly. These small imperfections are what make a Fraktur so charming. If you want a more exact drawing, design half the area, trace it onto tracing paper, and then turn over the tracing paper to reverse your drawing. Place the reversed tracing paper under the other half of your paper, and trace the design from it. Hold the papers up to a window or use a light box to make this easier.

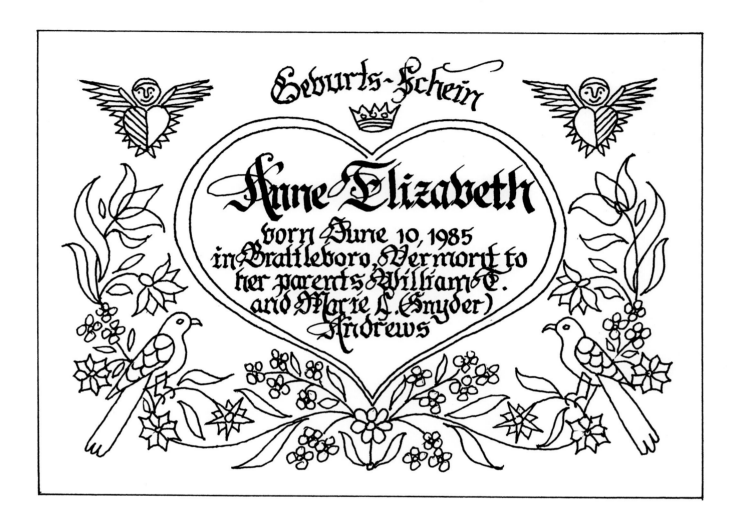

If you have waterproof ink, use the Hunt Crowquill pen to ink in the design lines. If you do not have waterproof ink, fill in the colors before outlining in black ink.

If you are right-handed, work from top to bottom, left first, then center, then right. Left-handers should work bottom to top, right first, then center, then left last. This lessens the probability that you will put your fingers in wet ink and smear something. Be very careful so that you won't have to start over again.

While inking over your pencil lines, you can make small changes in your drawing. At this time, you can also add flourishes to your letters and touch up edges that may not be smooth enough. When the ink is dry, erase all pencil lines not used in the design.

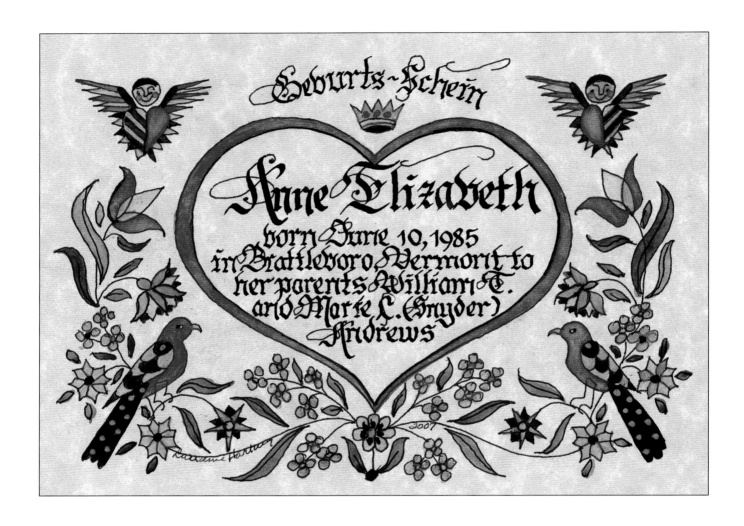

After all ink lines are dry, begin to fill in the colors. This step is shown on antique-color paper, so adjust your colors if you have been working on white paper. This is always a matter of personal taste. Use your imagination and favorite colors. Again, working from top to bottom for right-handers or bottom to top for left-handers will keep your fingers out of wet paint. Use the number 2 small brush for most of the small areas. The number 4 brush works well for putting in the teardrop shadows if you want to do this.

When all of the watercolor is dry, you can add small details over the paint, such as designs on the bird's wings or outlines around color areas if the color has hidden the original outlines.

Your second project is now complete! It can be matted or framed. Don't forget to sign and date your work.

House Blessing (Haus Segen)

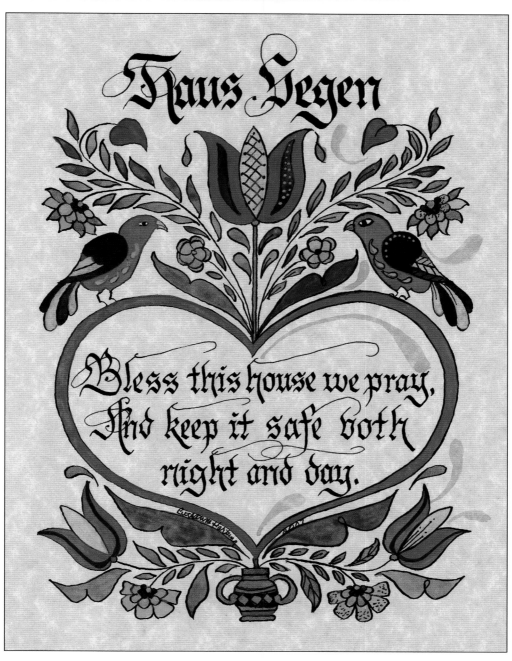

The third project will be 8 x 10 inches.

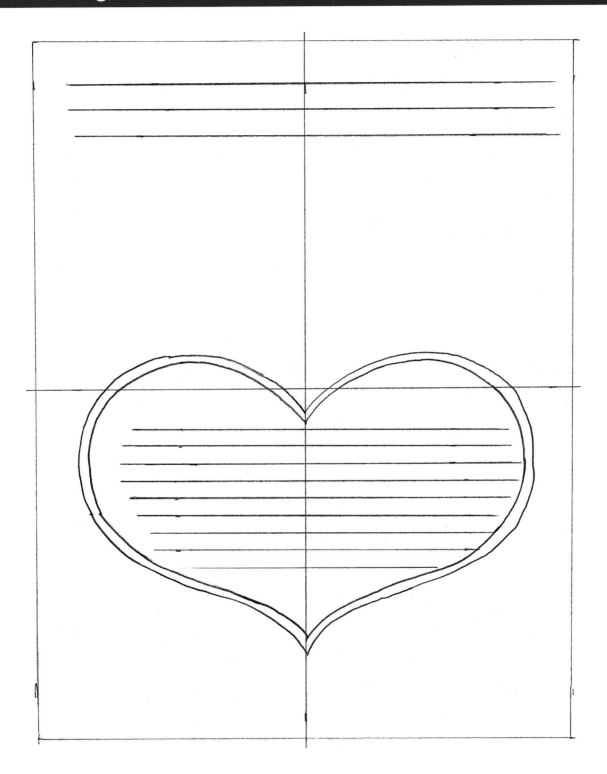

If you have been working the projects in order, by now you are familiar with beginning each project by dividing your design area in half both vertically and horizontally. Next, pencil in the heart (or other motif) that will contain your lettering. Pencil in these lines lightly, as they will eventually be erased. The size shown here is reduced to fit the page. You will need to redraw it on your paper at the 8 x 10 inch recommended size.

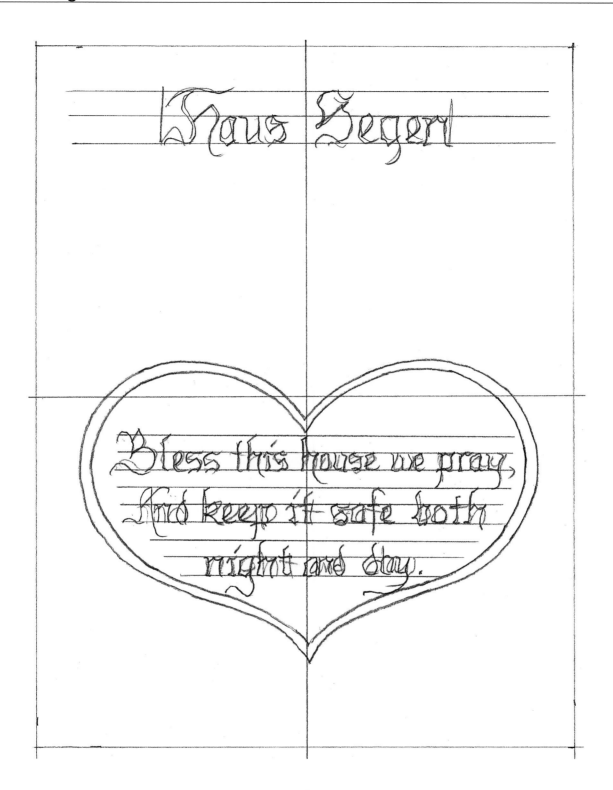

Lightly pencil in your letters as shown. If all the letters do not fit well, readjust the spacing of the lines. Count the number of letters and spaces in each line, and work out from the center to create equal margins on each end. Make all the pencil marks lightly so that they can later be erased.

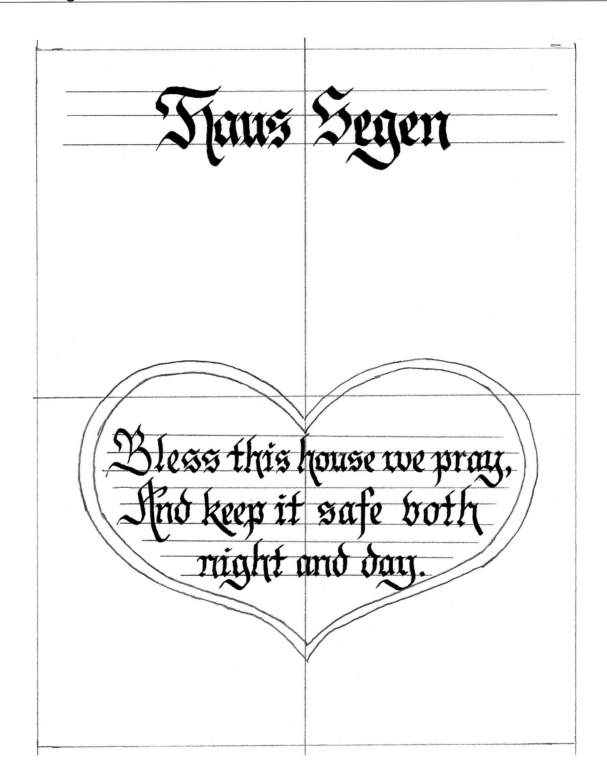

Ink in the heading with a Speedball C2 pen nib for the 8 x 10 inch drawing. For the smaller drawings, adjust the nib size accordingly. Use a smaller nib, perhaps a Speedball C4, for the saying in the heart. Ink in the outline of the heart with the Hunt Crowquill pen. Turn the paper as you go to avoid getting your fingers in the wet ink. Then put aside the work to let the ink dry.

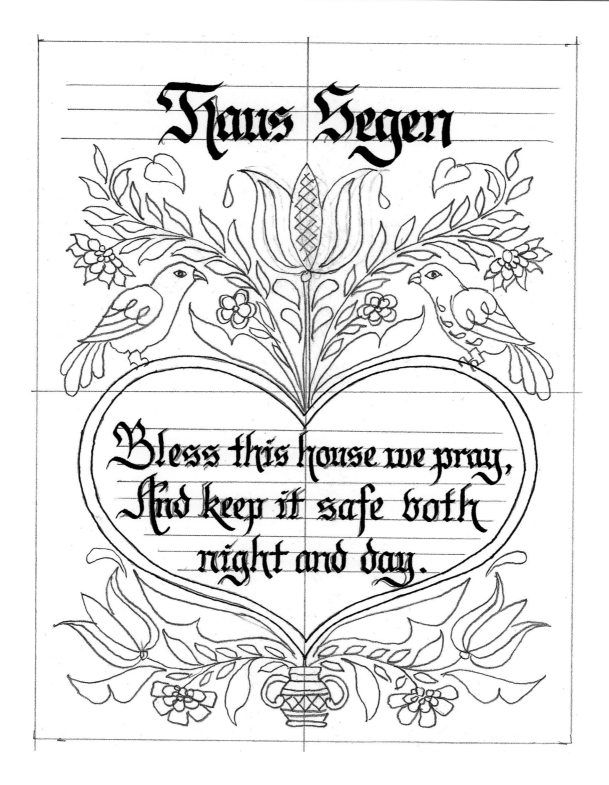

After the ink has dried, begin drawing the design in pencil. This is also a symmetrical design, but because part of the charm of Frakturs is in their informality, small differences in the size or placement of motifs are of small consequence. It is also fine to be as technically correct as possible, if you wish, by measuring the placement of all parts. Press lightly on the pencil, as any indentations created on the surface of the paper will show when the pencil lines are erased. This also allows you to change your mind and alter a design during this step.

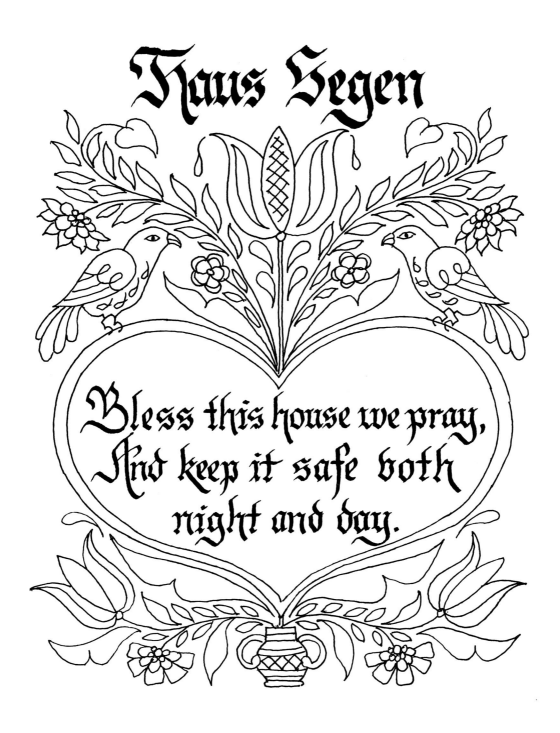

Now erase the lettering and border guidelines. If you have waterproof ink, draw in the design outlines with the Hunt Crowquill pen. Turn the paper as you go to avoid smearing the wet ink areas. Set aside to allow the ink to dry. If your ink is not waterproof, fill in the colors first. Then outline when the paint is dry.

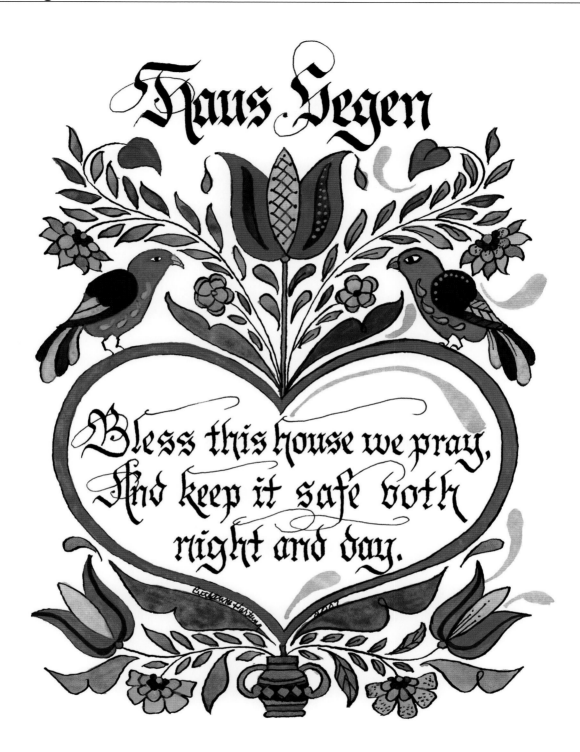

When the ink has dried, apply your colors. By now you may have a favorite color scheme, or you might still be experimenting. Who says leaves have to be green? Use your imagination and enjoy being creative. It's fun to try the same design over again with different color schemes. Use the size brush that is most comfortable—generally, the number 2 for smaller areas and the number 4 for larger areas. As you begin to work with larger designs, consider adding other size brushes to your tools.

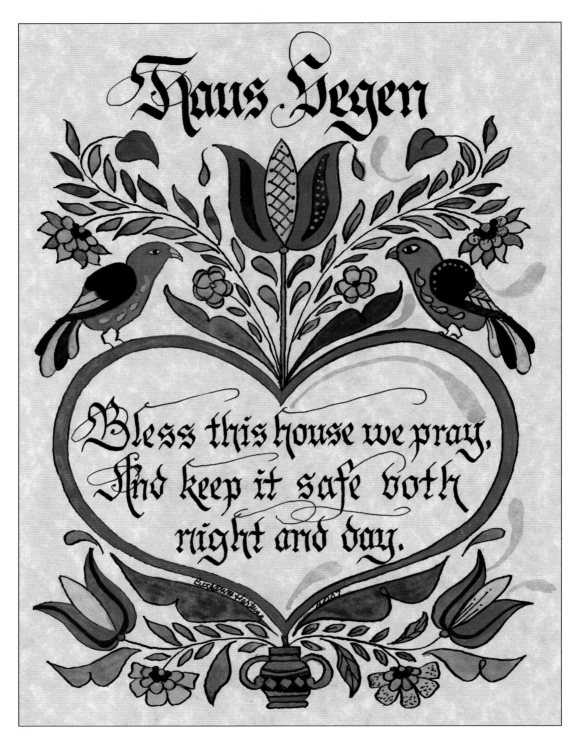

When the colors have dried, reoutline if needed, and add some small details with the Hunt Crowquill pen over the color areas. I've done half of the design this way so that you can see what a difference this makes. Also add flourishes to the letters if you want them.

When the ink and paint have dried, erase any pencil lines that still show.

Your third project is now complete! It can be matted or framed. Hang it in your own home or give it as a gift to a friend. Don't forget to sign and date your work.

Patterns

These patterns are offered as a helping hand as you begin your adventure into creating a Fraktur of your own. You can enlarge or reduce them to make their uses more flexible. If you are fortunate enough to have your own copier or computer, scanner, and printer, you can do this yourself. If not, a copy center near you will have the means of enlarging or reducing any design you want to use. Let the staff know the dimensions that you would like the image to be. They will help you with the process.

You can easily transfer the design to another piece of paper as follows: First trace the pattern onto a piece of tracing paper. Turn the tracing paper over and rub a contrasting color of chalk or graphite from a pencil over the reverse side of the tracing. Place the tracing paper, image side up, over the paper you intend to work on. Use small pieces of masking tape to hold the tracing paper in place. Trace over the original drawing with a hard pencil to transfer the lines onto the paper underneath. Be careful not to press so hard that the tracing paper tears.

Tracing is fine in the beginning, but it can inhibit your creativity if you depend on it too long. After a few projects, start trying to copy the images by hand to develop your own style and interpretation. Your purpose should be to design a Fraktur that looks like your own work, not someone else's. As you practice, you will develop more confidence in using your own design ideas. Have fun with it!

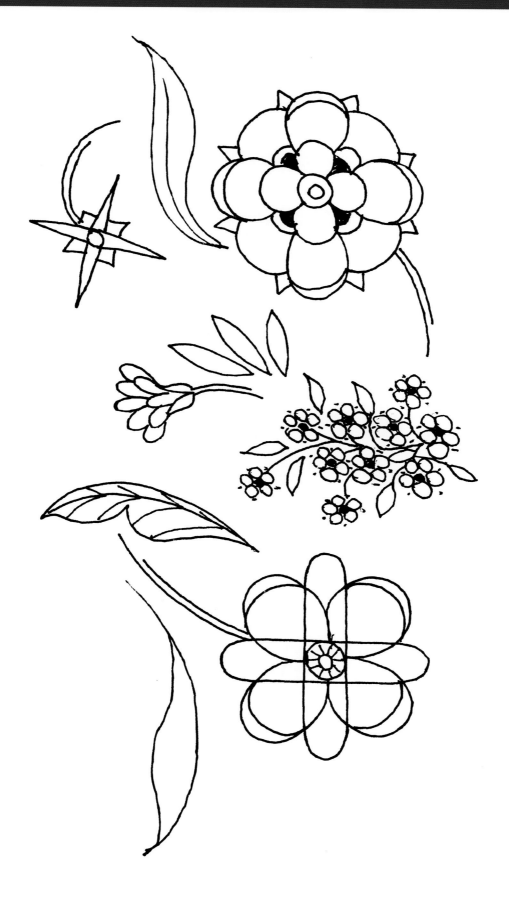

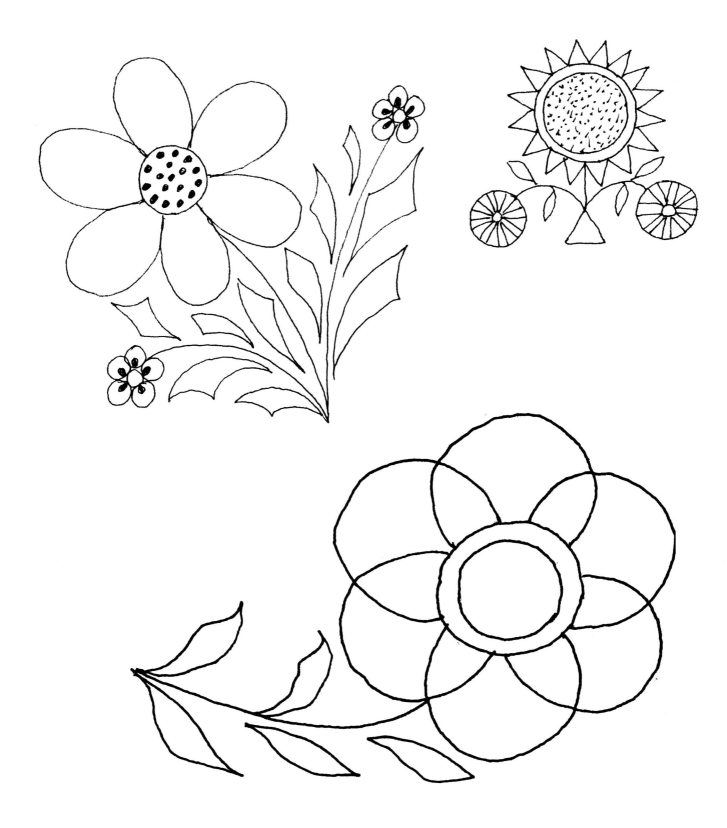

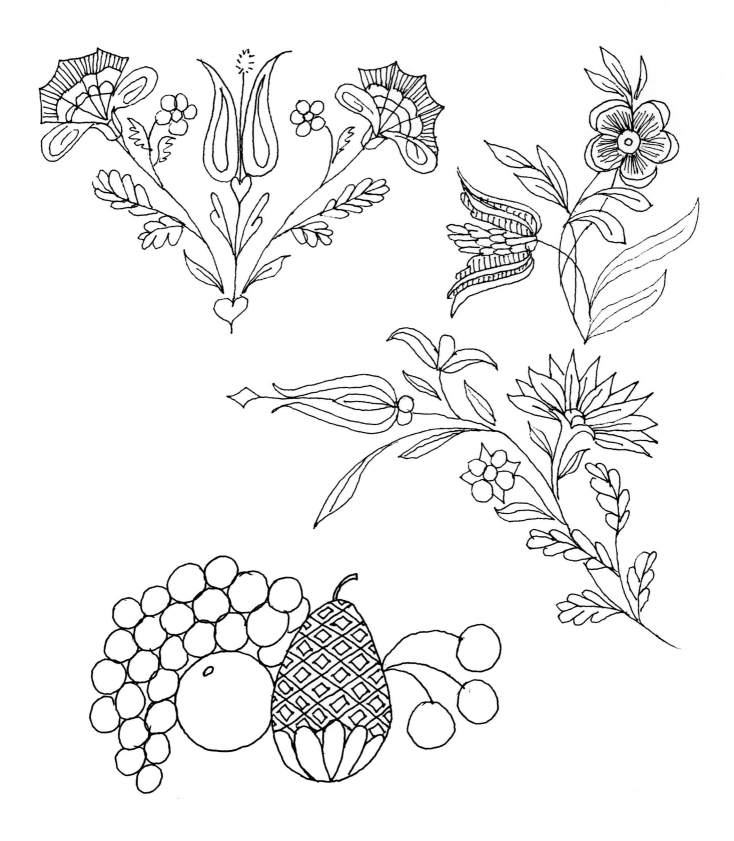

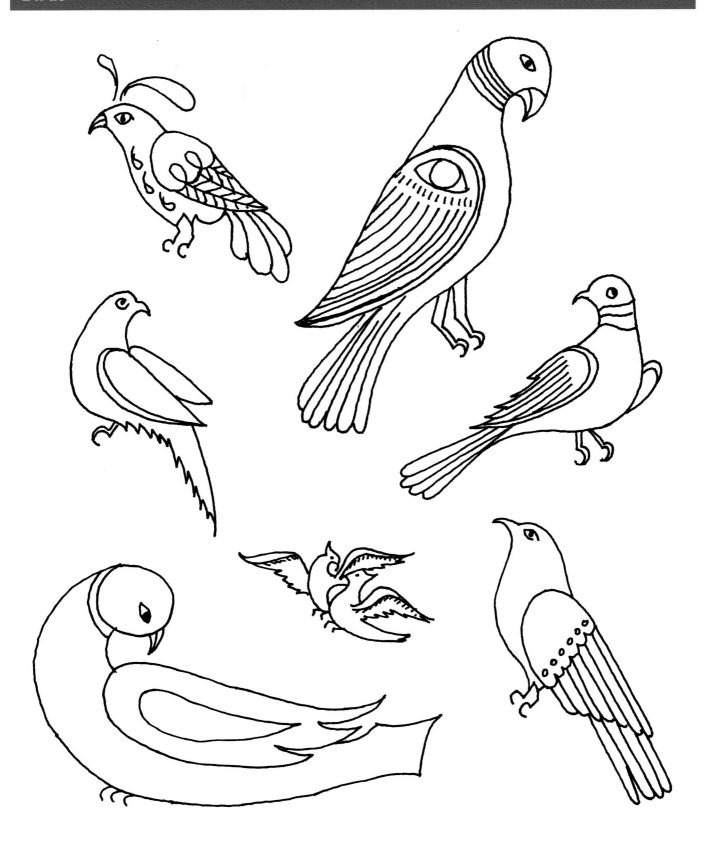

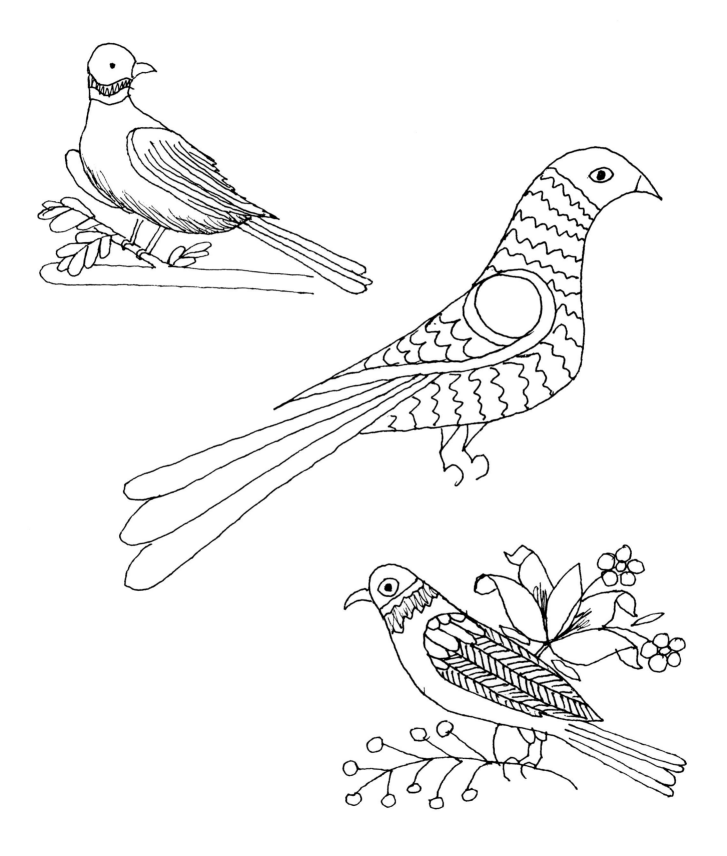

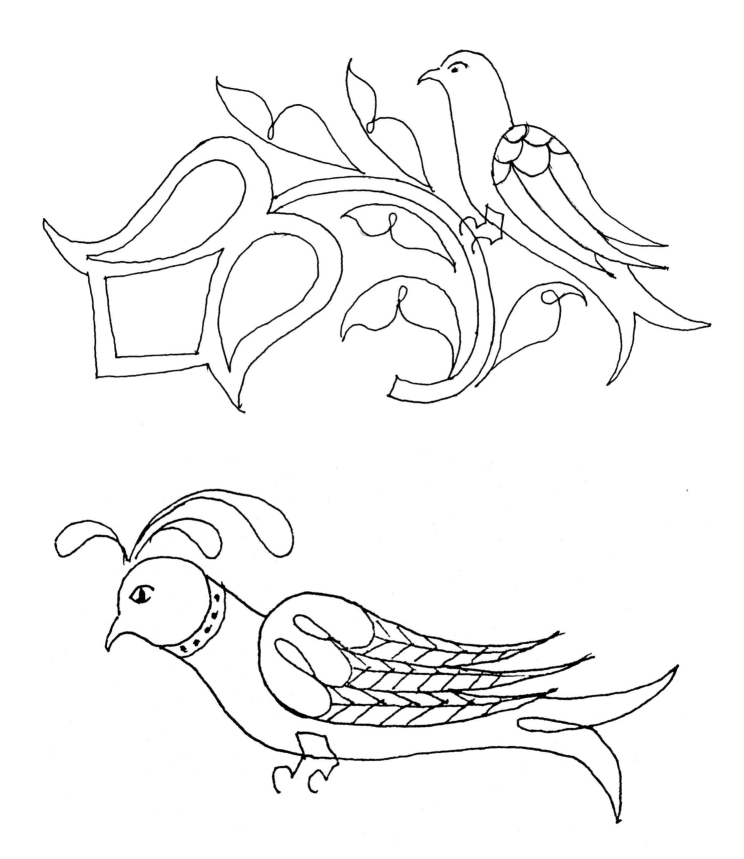

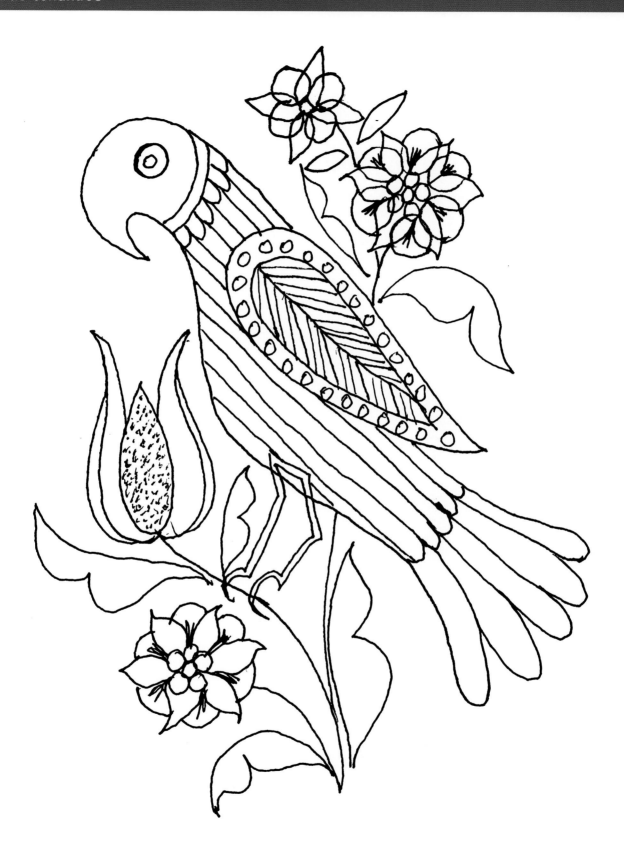

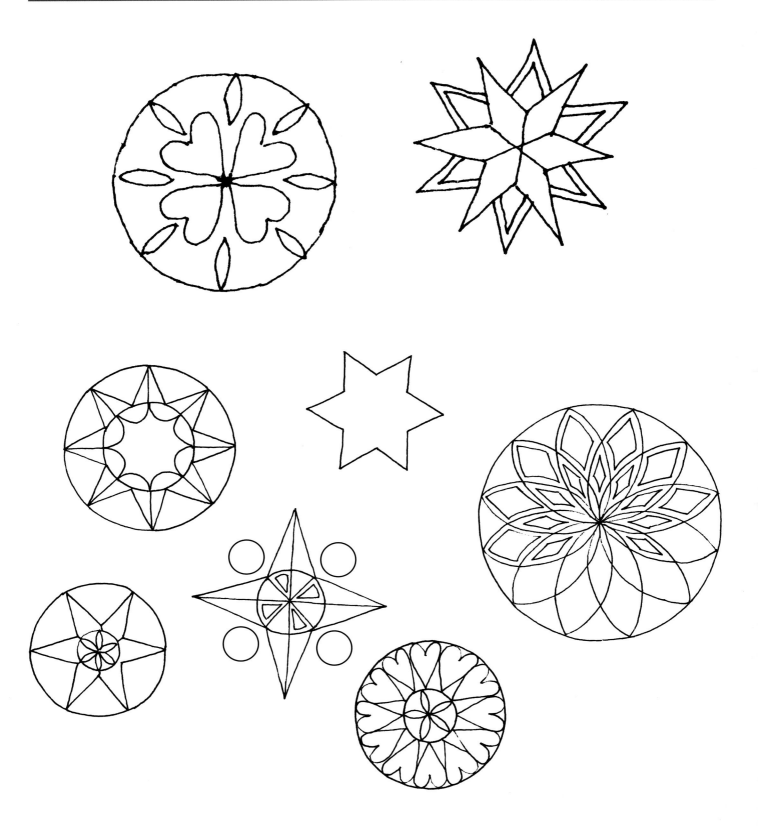

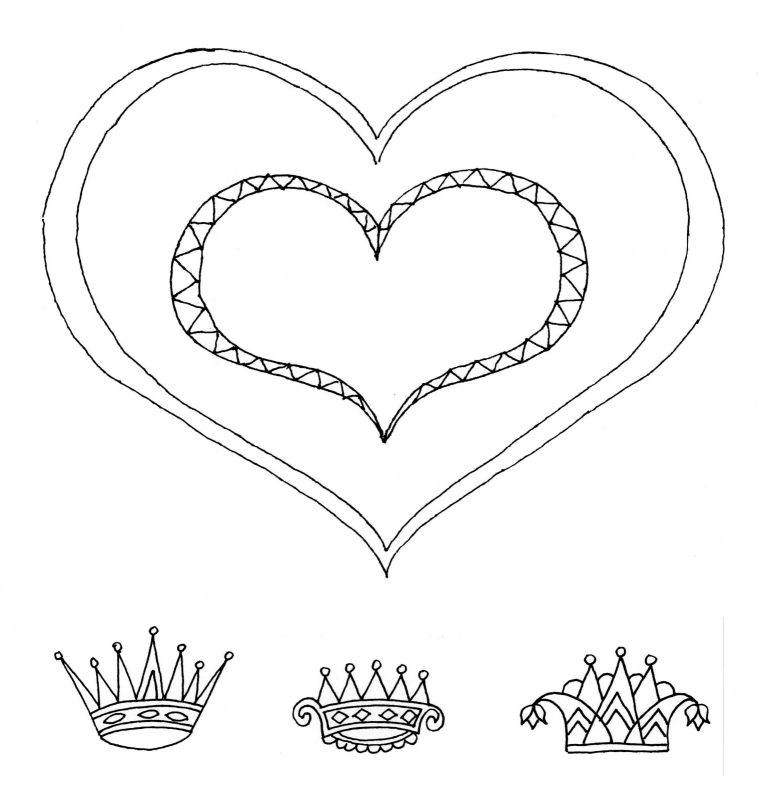

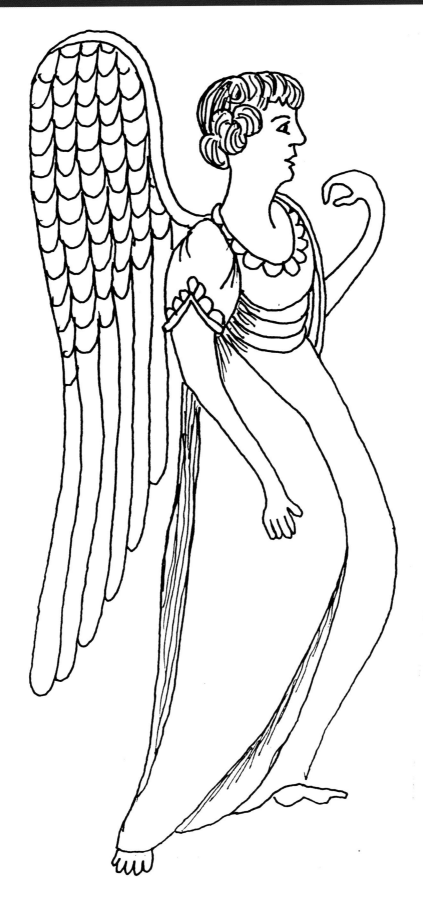

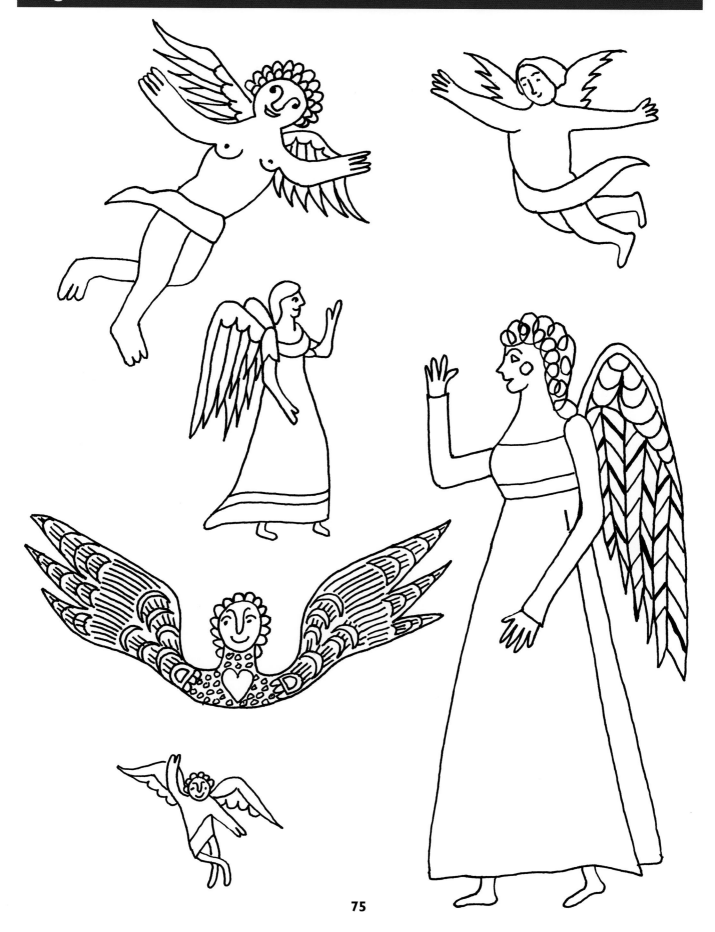

75

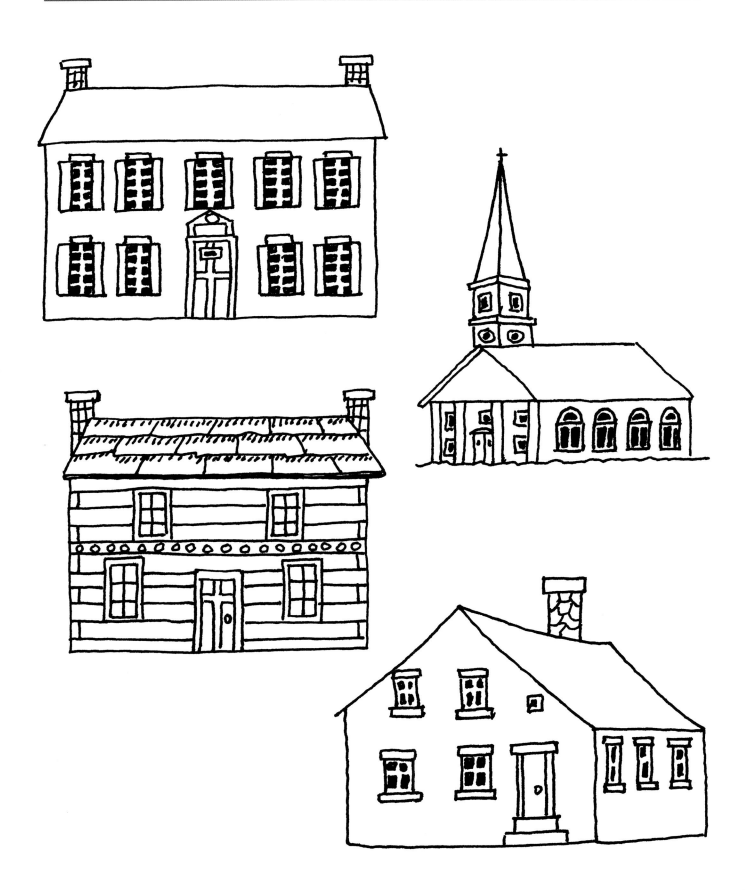

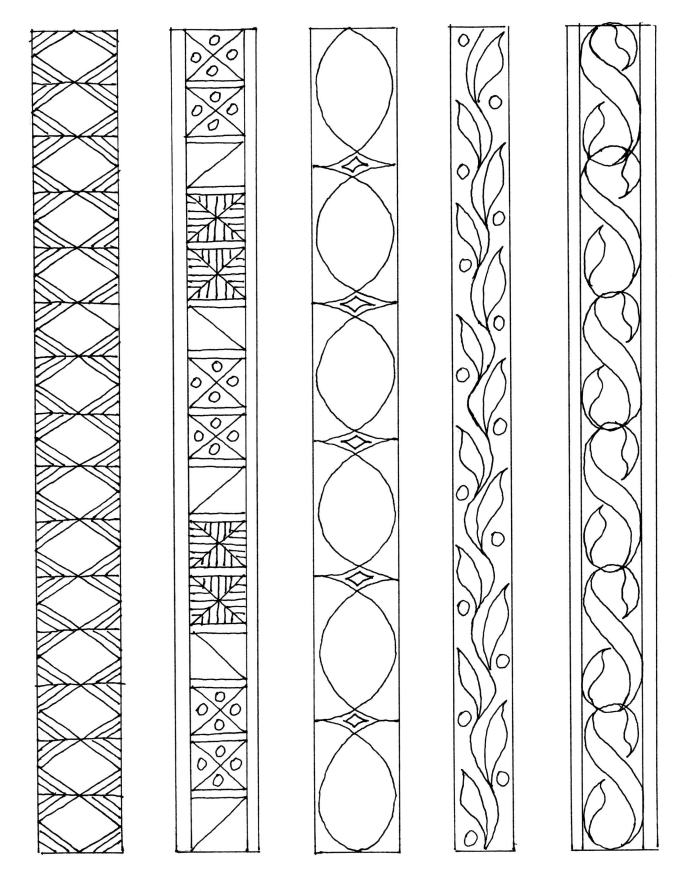

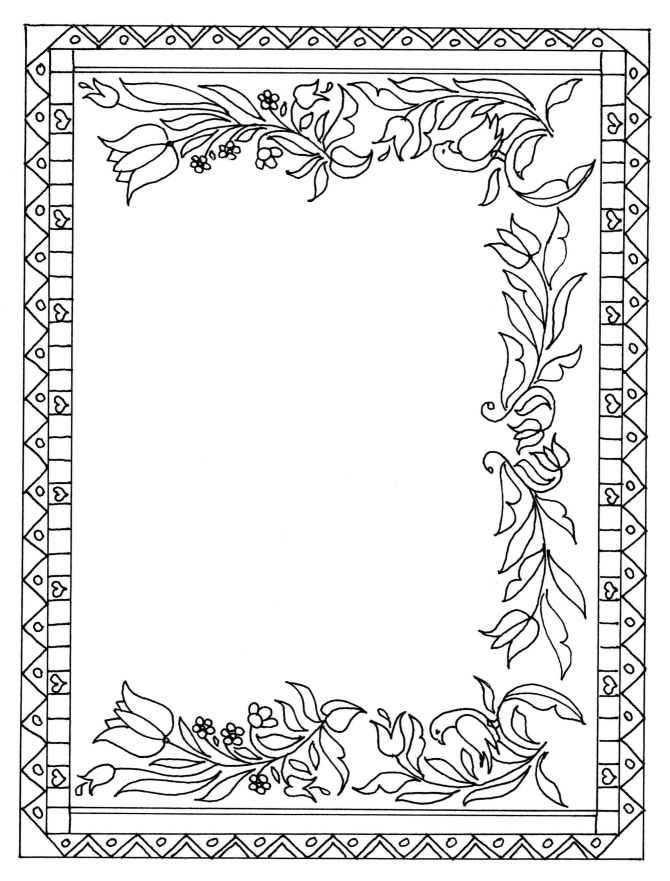

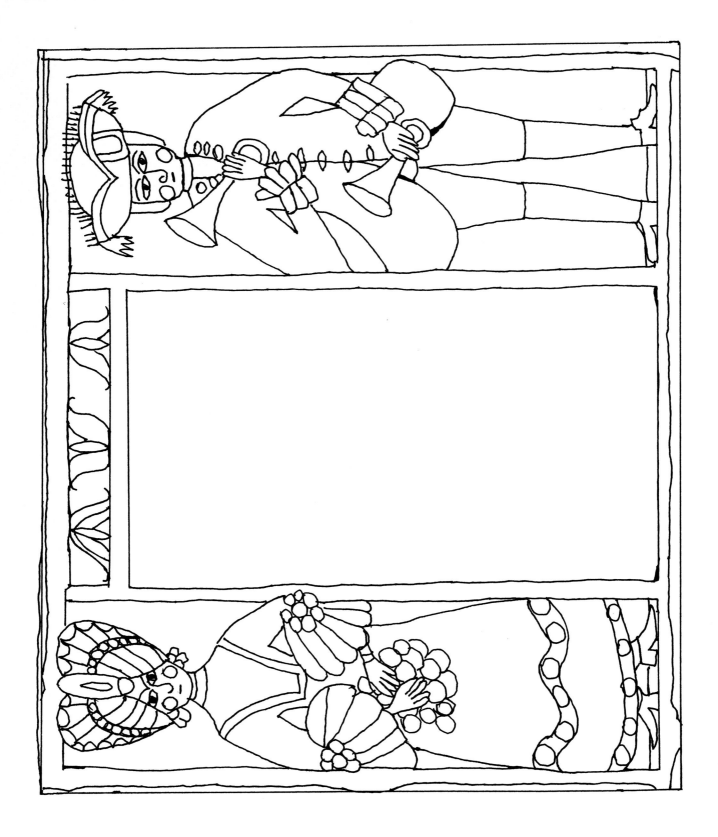

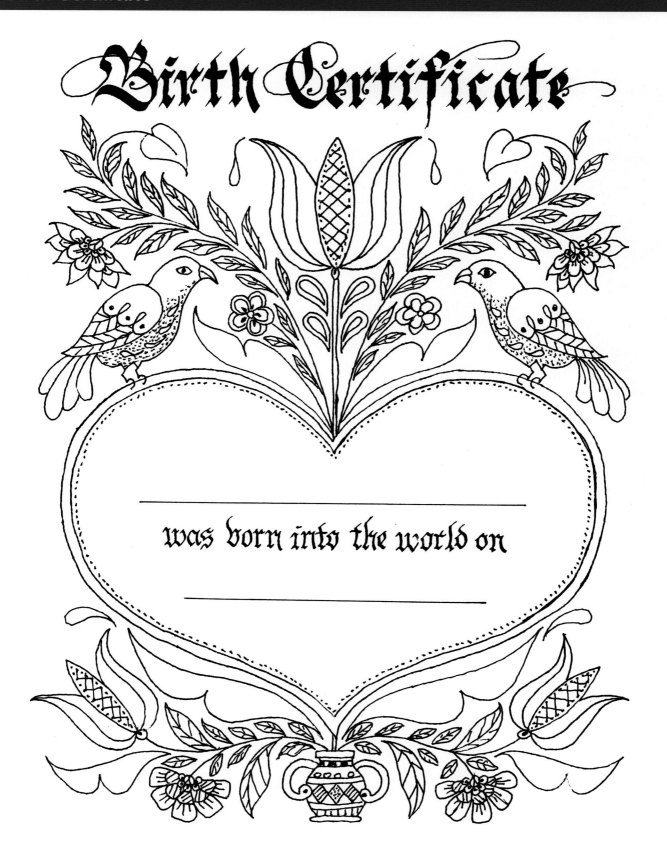

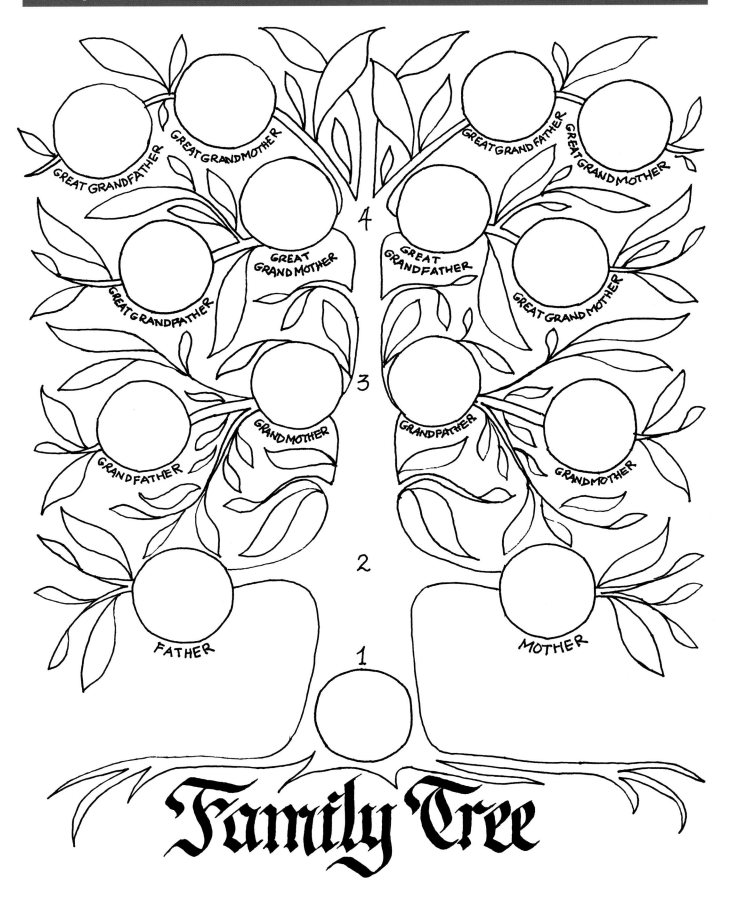

GREAT GRANDFATHER
GREAT GRANDMOTHER
GREAT GRANDFATHER
GREAT GRANDMOTHER

4

GREAT GRANDFATHER
GREAT GRANDMOTHER
GREAT GRANDFATHER
GREAT GRANDMOTHER

3

GRANDFATHER
GRANDMOTHER
GRANDFATHER
GRANDMOTHER

2

FATHER
MOTHER

1

Family Tree

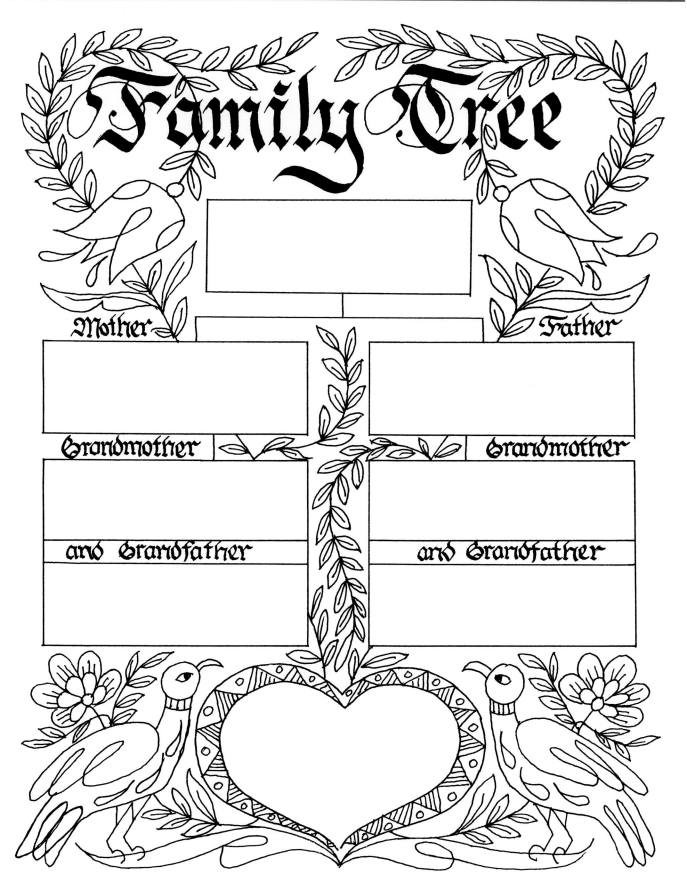

Family Tree

Mother

Father

Grandmother

Grandmother

and Grandfather

and Grandfather

Family Records

Marriages

Births

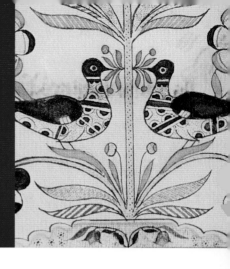

Gallery

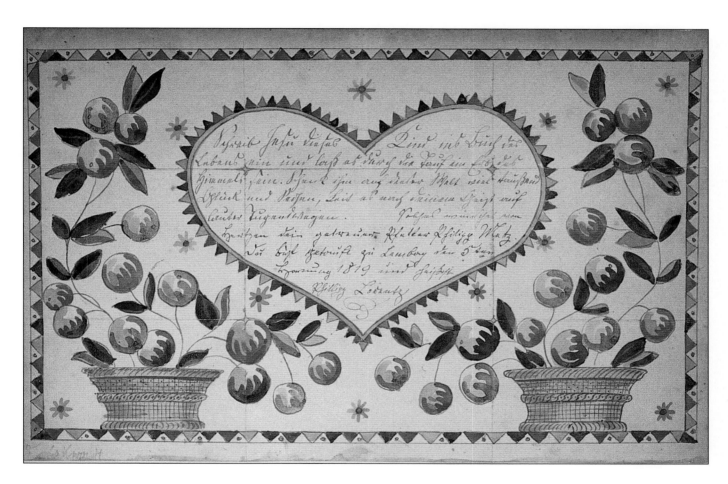

Here are some additional pieces by Fraktur artists from the past, in Europe as well as America. In many cases, the identity of the artist is unknown. These works will familiarize you with the motifs and how they were traditionally used on the documents.

Above: Art on paper combining calligraphy with design elements began in Europe. This baptismal letter, created in Alsace in 1819, is similar to a Pennsylvania Dutch Taufschein, *with the text in a symmetrical heart.* PHOTO BY DON YODER/ROUGHWOOD COLLECTION

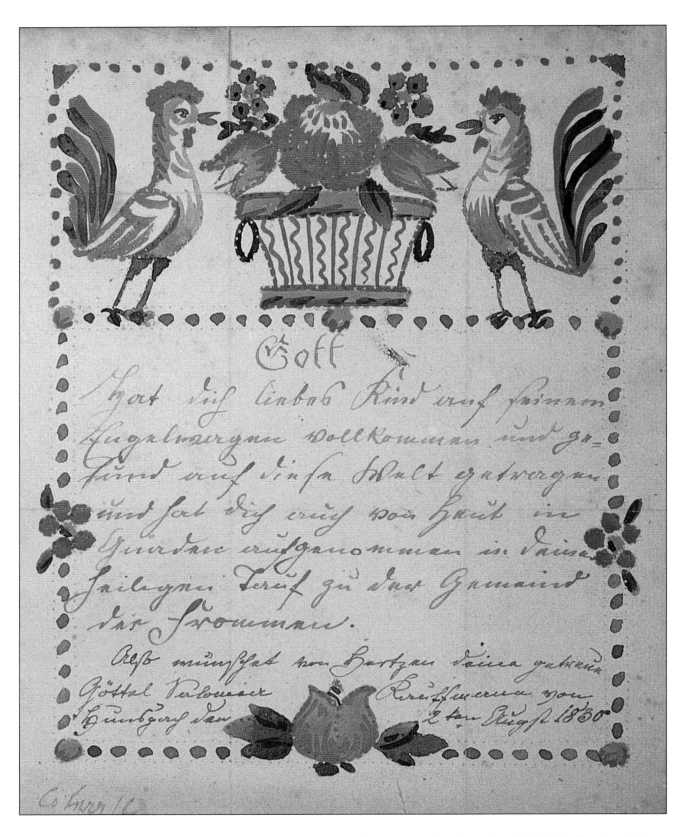

This is another early example of a baptismal letter from Europe, made in Hunspach, Alsace, in 1830. Notice the pinpricking technique around the design elements. PHOTO BY DON YODER/ROUGHWOOD COLLECTION

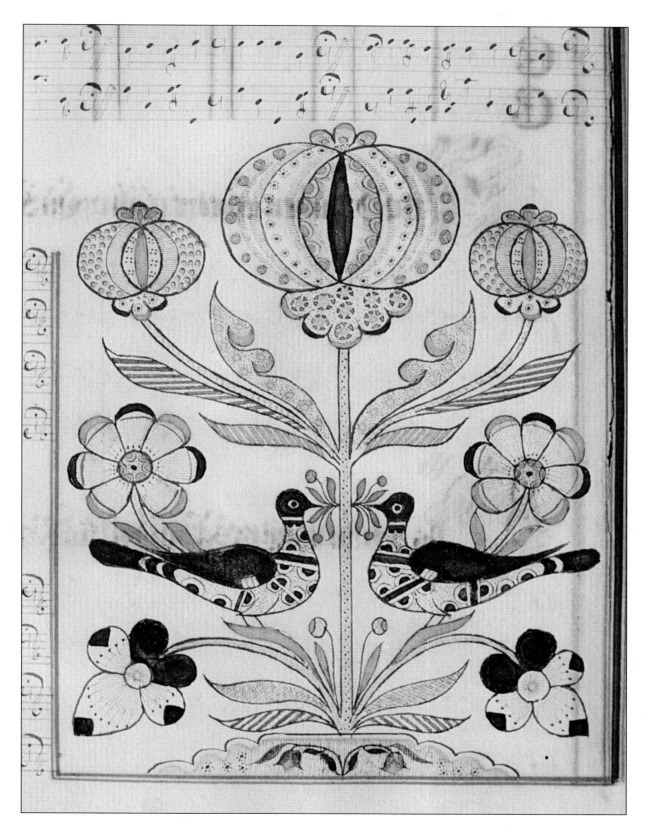

America's earliest Fraktur was produced at the Ephrata Cloister in Lancaster County, Pennsylvania, in the 1750s. The turtle-doves and large floral motifs were common on Ephrata pieces. The muted colors reflect the ascetic lifestyle of the brotherhood and sisterhood of the community. PHOTO BY DON YODER/PRIVATE COLLECTION

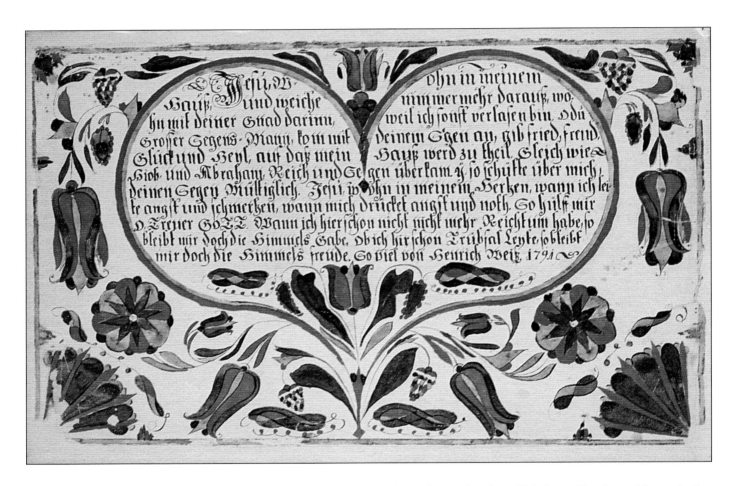

The Schwenkfelder religious community in Pennsylvania was a prolific producer of Fraktur. This house blessing, with text in the characteristic flat heart, was created in 1791 by the Montgomery County artist Henrich Weiss.

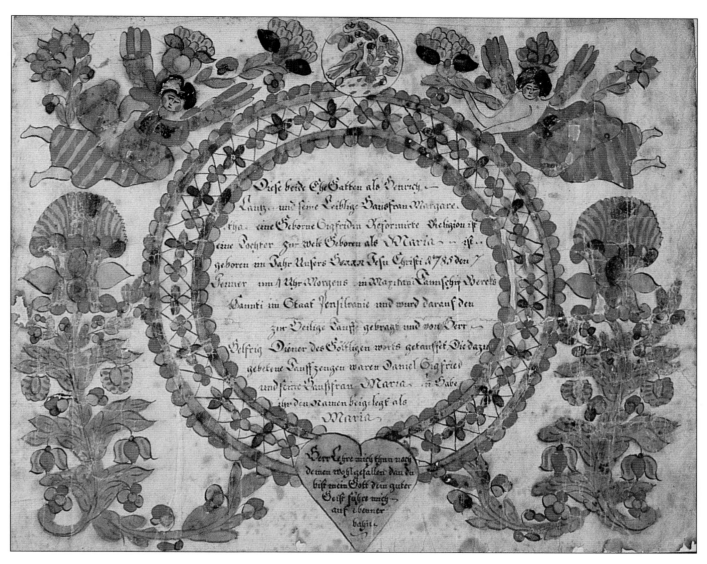

The Lutherans and Reformed among the Pennsylvania Dutch produced the largest number of Fraktur pieces, especially the Taufschein, *as they practiced infant baptism and placed great emphasis on dedicating each newborn child. This example is by the so-called Blowzy Angel Artist, who was active in Berks and Lehigh Counties in Pennsylvania in the eighteenth century.*

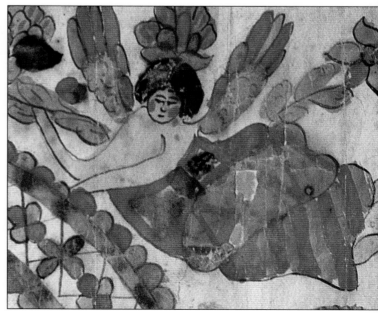

Detail showing the Blowzy Angel.

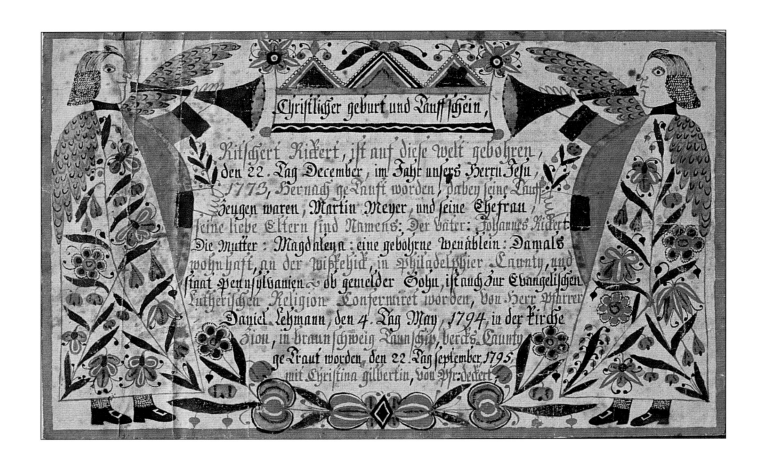

Another Taufschein *with trumpeting angels wearing eighteenth-century buckled shoes. The piece includes confirmation and marriage data as well.* PHOTO BY DON YODER

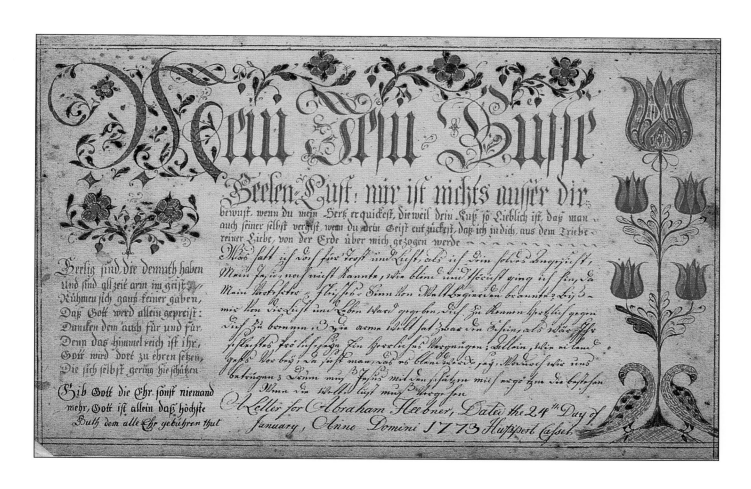

Schoolmasters made the Vorschrift, *or writing sample, as a gift for students. This one was made by Hubert Cassel in 1773.*

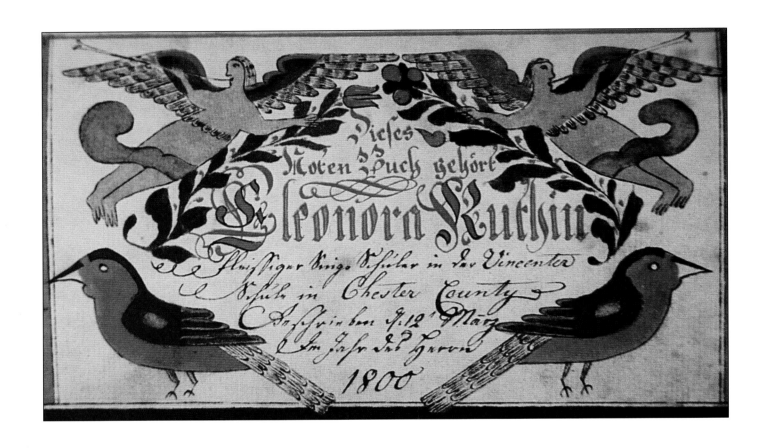

This bookplate was made by a schoolmaster in 1800 to identify the songbook of an "industrious pupil of music" at the Vincent School in Chester County, Pennsylvania. PHOTO BY DON YODER WITH PERMISSION OF THE HISTORICAL SOCIETY OF PENNSYLVANIA

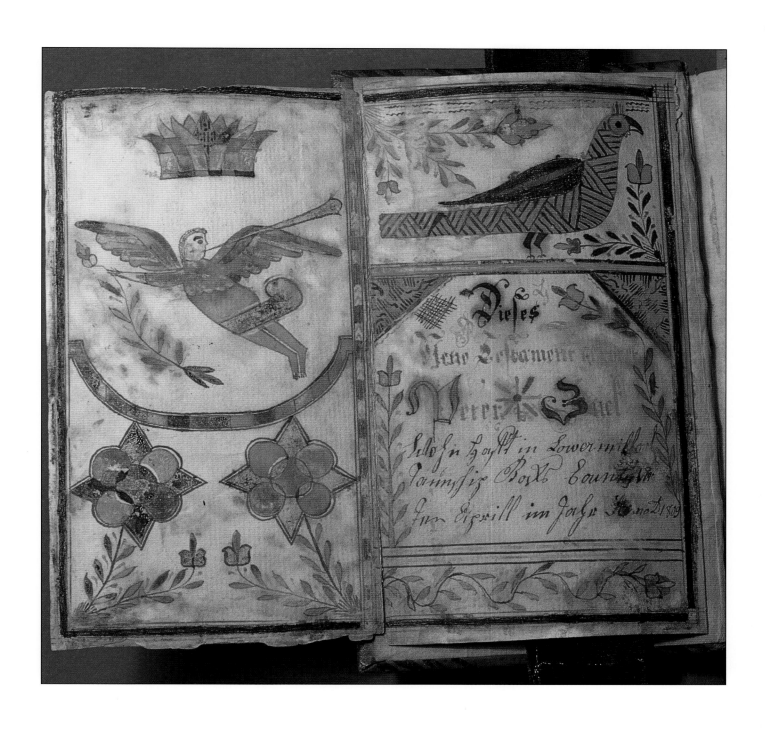

Peter Zuck created this double bookplate with a wide variety of motifs—crown, flowers, angel, and bird—in 1809. PHOTO BY DON YODER WITH PERMISSION OF THE FREE LIBRARY OF PHILADELPHIA

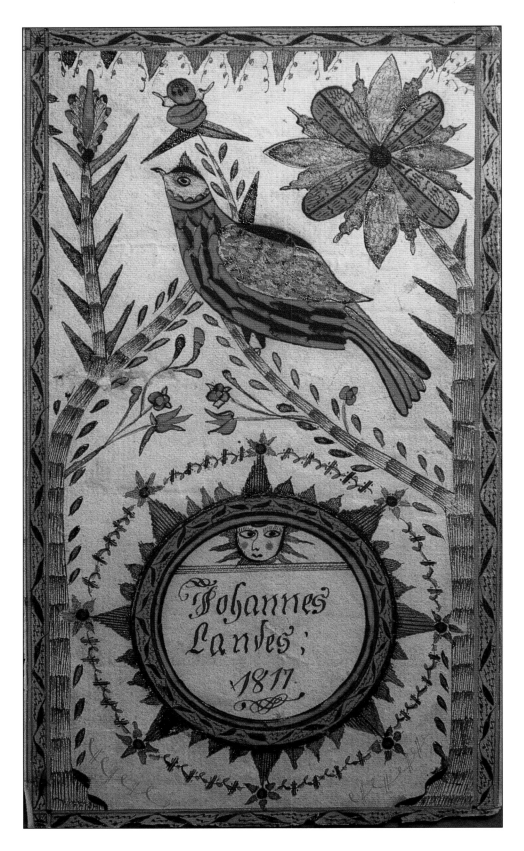

Another elaborate bookplate, made in 1817 by Johannes Landes.

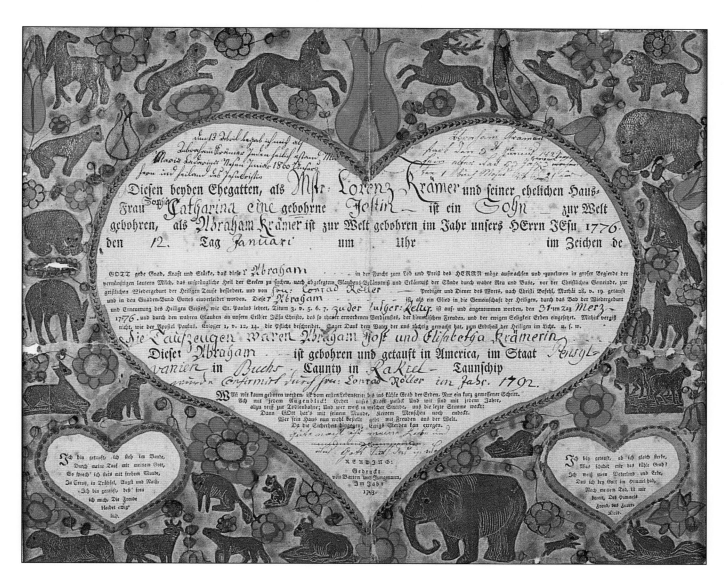

Printed Fraktur began with entrepreneurs in the 1780s. The designs were printed and colors and names were applied by hand. This early printed Taufschein *from Bucks County, Pennsylvania, produced in 1793, has the data about the birth and baptism inked in. It was made for the author's great, great, great, great uncle.* PHOTO BY DON YODER WITH PERMISSION OF FRANKLIN AND MARSHALL COLLEGE

The design for this book cover by Ruthanne Hartung combines traditional motifs with a more contemporary layout. BERKS COUNTY HISTORICAL SOCIETY

SUPPLIES

Dick Blick Art Materials
South Mall
3152 Lehigh St.
Allentown, PA 18103
610-791-7576
www.dickblick.com

Jerry's Artarama
www.jerrysartarama.com

John Neal, Bookseller
1833 Spring Garden St.
Greensboro, NC 27403
800-369-9598 or 326-272-6139
www.johnnealbooks.com

Michael's
www.michaels.com

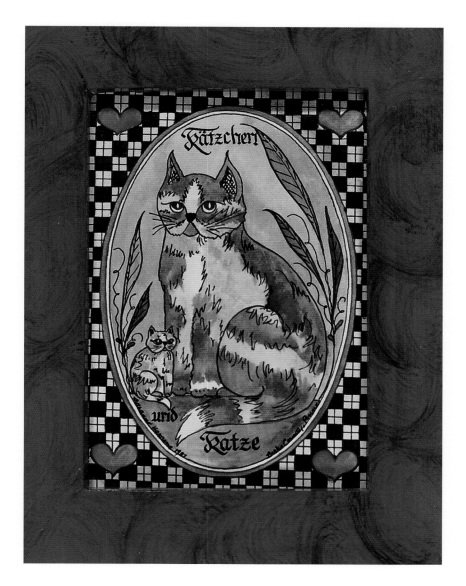

Cat and Kitten by Ruthanne Hartung.

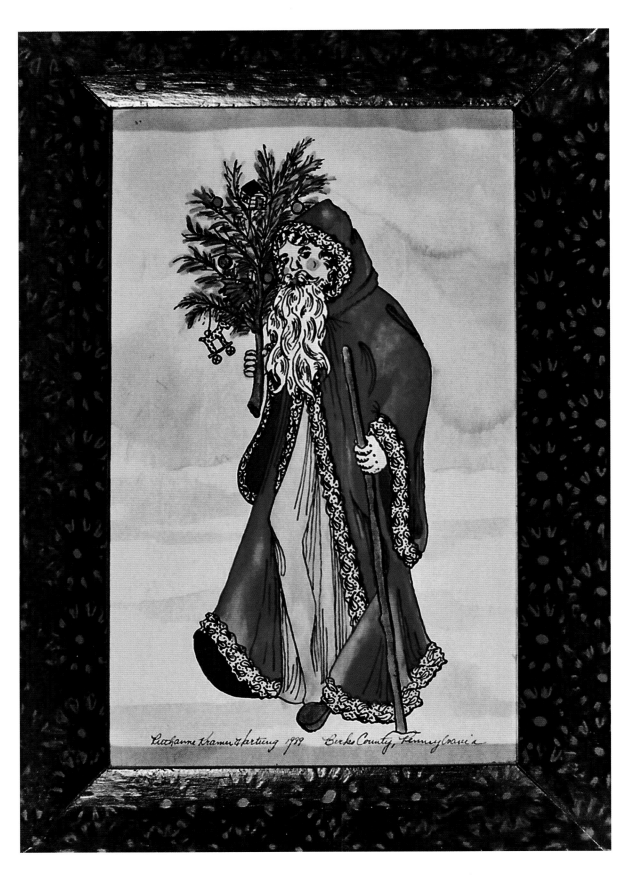

A Pennsylvania Dutch version of Saint Nicholas, or Santa Claus, by Ruthanne Hartung.

BIBLIOGRAPHY

Abrahams, Ethel E. *Frakturmalen und Schoenschreiben.* North Newton, KS: Mennonite Press, 1980.

Amsler, Cory M., ed. *Bucks County Fraktur.* Doylestown, PA: Bucks County Historical Society; Kutztown, PA: Pennsylvania German Society, 2001.

Bird, Michael S. *Ontario Fraktur.* Toronto, Canada: M. F. Feheley, 1977.

Borneman, Henry C. *Pennsylvania German Illuminated Manuscripts.* New York: Dover, 1973.

Chapman, Suzanne E. *Early American Design Motifs.* New York: Dover, 1974.

Douglass, Ralph. *Calligraphic Lettering.* New York: Watson-Guptill, 1949.

Earnest, Corinne, and Russell Earnest. *Fraktur: Folk Art and Family.* Atglen, PA: Schiffer, 1999.

Johnston, Edward. *Writing and Illuminating and Lettering.* London: Pitman; reprint, New York: Taplinger, 1978.

Lichten, Frances. *Folk Art of Rural Pennsylvania.* New York: Charles Scribner's Sons, 1946.

Moyer, Dennis K. *Fraktur Writings and Folk Art Drawings of the Schwenkfelder Library Collection.* Kutztown, PA: Pennsylvania German Society, 1997.

Rubin, Cynthia E., ed. *Southern Folk Art.* Birmingham, AL: Oxmoor House, 1985.

Shaw, Paul. *Black Letter Primer.* New York: Taplinger, 1981.

Shelley, Donald A. *The Fraktur Writings or Illuminated Manuscripts of the Pennsylvania Germans.* Allentown, PA: Pennsylvania German Folklore Society, 1961.

Shoemaker, Alfred L. *Check List of Pennsylvania Dutch Printed Taufscheins.* Lancaster, PA: Pennsylvania Dutch Folklore Center, 1952.

Solo, Dan E. *Gothic and Old English Alphabets.* New York: Dover, 1984.

Weiser, Frederick S., and Howell J. Heaney. *The Pennsylvania German Fraktur of the Free Library of Philadelphia.* 2 vols. Philadelphia: Free Library of Philadelphia; Breinigsville, PA: Pennsylvania German Society, 1976–77.

Wust, Klaus. *Virginia Fraktur.* Edinburg, VA: Shenandoah History Publishers, 1975.

Yoder, Don. *The Picture-Bible of Ludwig Denig: A Pennsylvania German Emblem Book.* New York: Hudson Hills Press, 1990.

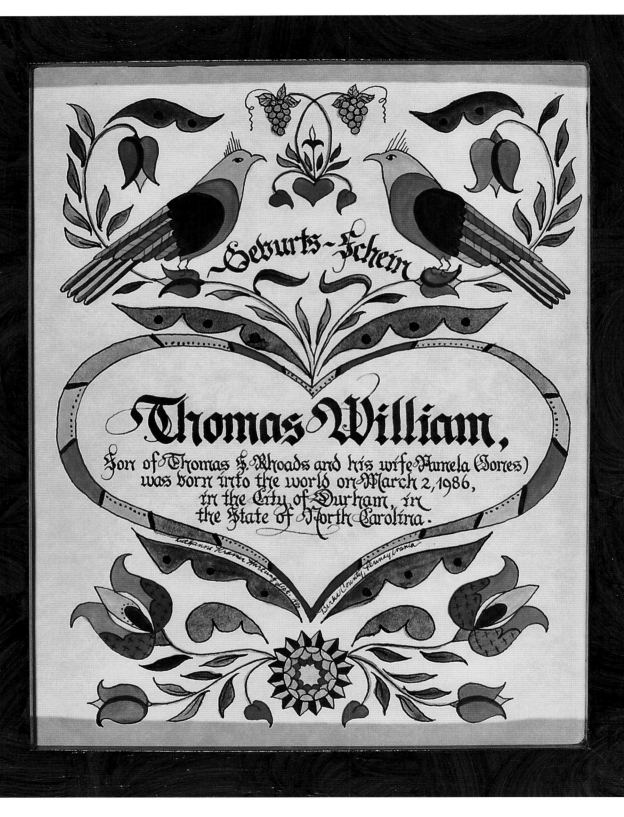